DOUGLAS GORDON

DOUGLAS GORDON

Organized by Russell Ferguson

Essays by
Michael Darling
Russell Ferguson
Francis McKee
Nancy Spector

Interview by
David Sylvester

The Museum of Contemporary Art, Los Angeles
The MIT Press, Cambridge, Massachusetts, and London, England

CONTENTS

Douglas Gordon has been recognized by many as one of the foremost artists of his generation. At only thirty-four years of age, he has established an elaborate lexicon of themes as the foundation for his diverse art practice. Although he works in many media, including photography, sculpture, and text, he is perhaps best known for a number of projected video installations based on classic films such as Alfred Hitchcock's *Psycho*, John Ford's *The Searchers*, and Martin Scorsese's *Taxi Driver*. Gordon locates and emphasizes his own signature themes within these films and, in so doing, pays tribute to the originals while at the same time creating some of the most inventive works of the last decade. It seems particularly fitting that Gordon's first major American monographic exhibition should happen here in Los Angeles, birthplace to many of Gordon's cinematic sources.

MOCA has a proud history of presenting cutting-edge international contemporary art and we are pleased to present such a comprehensive survey of work by this dynamic artist, deftly curated by Russell Ferguson. Russell initiated the exhibition during his tenure as MOCA's associate curator and has since assumed the post of chief curator at the UCLA Hammer Museum. Russell was assisted in the preparation of this exhibition by Michael Darling, assistant curator at MOCA, who also wrote an excellent essay for the catalogue. I would like to acknowledge the catalogue's other writers for their insightful contributions: Nancy Spector of the Guggenheim Museum in New York, Francis McKee, and the late David Sylvester. An incisive critic who earned the respect and admiration of colleagues worldwide, Sylvester passed away just as this book was going to press.

This exhibition extends MOCA's commitment to presenting

work by today's most important artists and would not be possible without the financial assistance of our visionary funders. We are grateful to Susan Bay-Nimoy and Leonard Nimoy; Catharine and Jeffrey Soros; The Thornton S. Glide, Jr. and Katrina D. Glide Foundation; The Peter Norton Family Foundation; the MOCA Contemporaries; and the New Media Project. Additional assistance for the exhibition catalogue was provided by Art for Arts Sake. I would like as well to extend my personal thanks to our Board of Trustees for their unwavering support and wisdom: Audrey M. Irmas, Chair; Gilbert B. Friesen, President; Dallas P. Price, Vice Chair; Bob Tuttle, Vice Chair; Dean Valentine, Vice Chair; Geraldine Alden, Ph.D.; John Baldessari; Susan Bay-Nimoy; William J. Bell, Jr.; Ruth Bloom; Vivian Buehler; Betye Monell Burton; E. Blake Byrne; Clifford J. Einstein; Beatrice Gersh; Lenore S. Greenberg; Wonmi Kwon; Lillian Pierson Lovelace; T. Willem Mesdag; Jane F. Nathanson; Frederick M. Nicholas; Genevieve Robert Reitman; Richard Riordan; Douglas R. Ring; Michael Schreter; Richard Shapiro; Pamela Hastings Smith; Thomas Unterman; Councilman Joel Wachs; and Lewis N. Wolff.

Finally, I would like to express my gratitude to Douglas Gordon, whose collaboration enhanced all aspects of the exhibition and the accompanying catalogue.

Jeremy Strick

ACKNOWLEDGMENTS

This exhibition has been in development for a number of years, and would not have been possible without the sustained commitment of a large group of dedicated people. Foremost among them is Douglas Gordon himself, who has been a very active participant in every stage of the process. Of course, it is Douglas's extraordinary work as an artist that has made this exhibition possible and worth pursuing, but his help with a myriad of organizational matters — from the catalogue to installation, loans, funding, tour planning, and the development of educational programs — is evidence of his total dedication to the project.

At MOCA, the project was initially given the go-ahead by former director Richard Koshalek. MOCA's current director, Jeremy Strick, has wholeheartedly embraced the exhibition and realized its importance since assuming his position in 1999. Chief Curator Paul Schimmel has also been a great supporter since the initial planning stages of the exhibition, and as always has offered his estimable advice throughout. In March of this year I left MOCA to become chief curator at the UCLA Hammer Museum, and I owe all my colleagues at MOCA an enormous debt of gratitude for their unwavering commitment to the realization of this exhibition. I would also like to thank Ann Philbin, director of the Hammer, for her extraordinary flexibility in making it possible for me to see this project through to its conclusion.

An exhibition of this scale and complexity is an expensive undertaking. We are particularly grateful therefore to the supporters who have made such an ambitious project possible. We owe a sincere debt of gratitude to Susan Bay-Nimoy and Leonard Nimoy; Catharine and Jeffrey Soros; The Thornton S. Glide, Jr. and Katrina D. Glide Foundation; The Peter Norton Family Foundation;

the MOCA Contemporaries; and the New Media Project. I would also like to thank Art for Arts Sake for their support of the catalogue.

Douglas Gordon has been fortunate to work with some of the world's most important galleries, all of whom have generously offered research materials, photographs, staff time, and advice toward the successful realization of this exhibition. At the Gagosian Gallery in New York, Larry Gagosian, Kay Pallister, Ealan Wingate, and Zach Miner have been invaluable supporters. At the Lisson Gallery in London, Nicholas Logsdail and Pilar Corrias have been indispensable allies, while Yvon Lambert in Paris has likewise lent his unqualified support.

The lenders to the exhibition deserve our special thanks. Michael and Eileen Cohen, Andrea Fortunoff, Invild Goetz, Audrey Irmas, Sean and Mary Kelly, Rita Krauss, Yvon Lambert, Cari and Max Lang, Mark and Vanessa Mathysen-Gerst, Erik and Heidi Murkoff, Eileen and Peter Norton, Patrizia Sandretto Re Rebaudengo, Jerome Stern, and Sabine Walli have all lent major works from their personal collections. We are very grateful to Thomas Krens, director of the Guggenheim Museum; Lars Nittve, former director of the Tate Modern; and Gijs van Tuyl, director of the Kunstmuseum Wolfsburg, for their willingness to lend crucial works from the collections of their respective institutions. Both Gagosian and Lisson galleries have also contributed important loans.

The cooperation of Hank Garvin, Heidi Grunt and Jane Smith of the 29 Palms Inn and Gwen Deglise, Margot Gerber, and Dennis Bartok of the American Cinematheque allowed us to expand the exhibition beyond the walls of the museum and realize exciting off-site projects. Our deep thanks also go to Susan Cahan of the Peter Norton Family Foundation, whose early commitment was

crucial in making the screening of 5 *Year Drive-By* possible.

My colleague at the Solomon R. Guggenheim Museum in New York, Nancy Spector, has been an unflagging champion of Douglas's work for many years and has contributed greatly to this exhibition's realization. It was her suggestion originally that we work together on an exhibition of Gordon's work. I am delighted to work with Nancy at the Guggenheim and Tom Eccles at the Public Art Fund in New York as partners in the exhibition's tour. I am also extremely happy that the exhibition will be seen at the Hirshhorn Museum and Sculpture Garden in Washington, D.C., thanks to the commitment of Chief Curator Kerry Brougher.

An exhibition as ambitious as this in terms of scale, cost, and technical difficulty, can only be brought into existence with the intense involvement of an experienced staff. MOCA Exhibitions Production Manager Brian Gray heads one of the most well-respected installation teams in the country, praised by artists and curators alike for their professionalism, expertise, and good humor. Key to the effort are Chief Exhibition Technician Jang Park Exhibitions Production Coordinator Zazu Faure, Media Arts Technical Manager David Bradshaw, Media Arts Technician Tina Bastajian, Exhibition Technicians Monica Gonzalez, Barry Grady, Shinichi Kitahara, Jason Storrs, Valerie West, and a great crew of part-time installers. Douglas Gordon's close collaborator, Robert Ross, offered invaluable advice and guidance throughout the installation process.

The complexities of loans and shipping have been ably handled by Chief Registrar Robert Hollister and Associate Registrar Rosanna Hemerick, while special projects have received dedicated attention by Michelle Bernardin and Caroline Blackburn. Caroline has also spearheaded a very sophisticated program of lectures, further enriching the offerings of the exhibition. The crucial tasks

of fundraising have been handled by Director of Development Paul Johnson and his team of Robert Crouch, Stephanie Graham, Kristen Kenyon, and Denise Therieau, while publicity has been taken up with energy by Communications Director Mary Lou Rutberg, Katherine Lee, and Heidi Simonian, with assistance from Jennie Prebor of Fitz & Co. The expert advice of my MOCA colleagues in the curatorial department is always something I can count on, and Senior Curator Ann Goldstein, Curator Connie Butler, Curator of Architecture and Design Brooke Hodge, Associate Curator Alma Ruiz, and Manager of Exhibition Programs and Curatorial Affairs Stacia Payne, as well as Beth Rosenblum, Julia Langlotz, Rebecca Morse, and Virginia Edwards, have been tremendous cohorts throughout the process.

The complexities of exhibition catalogue production have been efficiently and professionally handled by MOCA Senior Editor Lisa Mark, with her colleagues Jane Hyun and Elizabeth Hamilton. I am constantly impressed by their combination of skill and sensitivity. The striking design of the catalogue is the work of Bruce Mau Design, working in close collaboration with the artist. We are thankful for the valuable contributions of Bruce Mau, Amanda Sebris, and Catherine Rix at the Mau studio toward the realization of this publication. Once again, Roger Conover and The MIT Press have been the best of partners in co-publication. The insightful essays by Nancy Spector, Francis McKee, and Michael Darling, in addition to the wonderful interview between Douglas Gordon and David Sylvester, have advanced the study of Douglas's work to a considerable degree, and will no doubt have a lasting impact on how it is interpreted in the future.

David Sylvester died just as this book was about to go to press. With his passing the artworld has lost one of its giants. His contributions to our understanding of twentieth-century art are ines-

timable, and we are honored that he chose to conduct this interview with Douglas Gordon even though he was already very ill.

It was Thomas Lawson who first introduced me to the work of Douglas Gordon, and his insights have been enormously helpful to me. Many others have also been generous with their time and contributed in innumerable ways to the realization of this exhibition. Among them are Sam Ainsley, Barry Barker, Kathleen Bartels, Pierre Bismuth, Fiona Bradley, Eileen Cohen, Lynne Cooke, Mark Francis, Anna Gaskell, David Harding, Karin Higa, Casey Kaplan, James Lingwood, Eugenio Lopez, Patricia Martin, Jeremy Millar, Jonathan Monk, Philip Monk, Susan Morgan, Ross Sinclair, and Nicolai Wallner.

In conclusion, it is my pleasure to thank Assistant Curator Michael Darling, who has worked on this exhibition from the beginning, and who stepped up to coordinate it at MOCA after I left the museum. I owe him my deepest thanks for his unfailing commitment to every aspect of the project. While his essay in this book is testimony to his intellectual engagement with Gordon's work, he was equally engaged with countless organizational matters. He has handled all of them with the aplomb and sensitivity that I have come to expect from him, but not, I hope, to have taken for granted.

Russell Ferguson

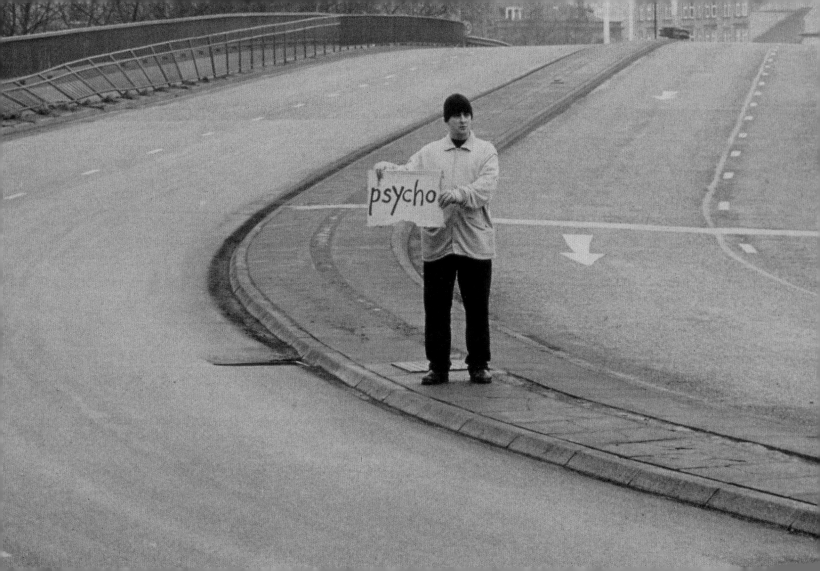

TRUST ME
RUSSELL FERGUSON

In 1993 Douglas Gordon made a photograph of himself as a
hitchhiker, holding a placard addressed to passing drivers. Where
one would expect to see a destination written, one reads instead:
"Psycho." Invite him along at your own risk. Anyone willing
to trust Gordon enough to let his work penetrate his or her
consciousness is also inviting a series of potentially destabilizing
shifts in perception.

Time is the first element to be made strange, often stretched
out into extremities of languor, sometimes moving backwards
and forwards, in and out of synch. The narrator of James Hogg's
The Private Memoirs and Confessions of a Justified Sinner (1824),
a Scottish novel of great significance to Gordon, evokes the
"terrors and mental torments" produced in him by losing his
grip on the passage of time:

> To be in a state of consciousness and unconsciousness, at the same
> time, in the same body and same spirit, was impossible. I was
> under the greatest anxiety, dreading some change would take
> place momently in my nature; for of dates I could make nothing:
> one-half, or two-thirds of my time, seemed to me totally lost.[1]

In "Art and Objecthood," Michael Fried refers to "the utter per-
vasiveness — the virtual universality — of the sensibility or mode
of being that I have characterized as corrupted or perverted by
theater."[2] Despite the fact that much of Gordon's work unfolds
over time and is thus "theatrical" in a quite literal sense, the
distortions and extensions of normal time that are pervasive in
it also contribute to a profoundly anti-theatrical experience.

Gordon takes the theatrical and twists it. He promises to tell us a story, then does something else. Realistically, no one can watch the whole of *24 Hour Psycho* (1993), which consists of Alfred Hitchcock's film *Psycho* (1960) slowed down so that a single, continuous viewing lasts for twenty-four hours. While we can experience narrative elements in it (largely through familiarity with the original), the crushing slowness of their unfolding constantly undercuts our expectations, even as it ratchets up the idea of suspense to a level approaching absurdity. As Walter Benjamin wrote in "The Work of Art in the Age of Mechanical Reproduction," "The painting invites the spectator to contemplation; before it the spectator can abandon himself to his associations. Before the movie frame he cannot do so. No sooner has his eye grasped a scene than it is already changed It cannot be arrested."[3] In *24 Hour Psycho*, Gordon gives the audience both experiences simultaneously. The pace is slow enough for contemplation and association, yet retains enough forward movement to retain a strong, if frustrating, narrative thrust.

Gordon himself has described the process in terms of a slow pulling apart: "The viewer is catapulted back into the past by his recollection of the original, and at the same time he is drawn into the future by his expectations of an already familiar narrative…. A slowly changing present forces itself in between."[4] In the end, viewers are led away from the temptations of narrative into a constantly renewing now, as if unwillingly confirming Fried's famous conclusion: "Presentness is grace."[5]

If one becomes incapable of experiencing time as a steady, unbroken stream that passes for everyone at the same uniform rate then panic is a likely result. However, after panic, and terror, and disorientation, there remains the present. If time cannot be experienced as sequential, then it must be experienced

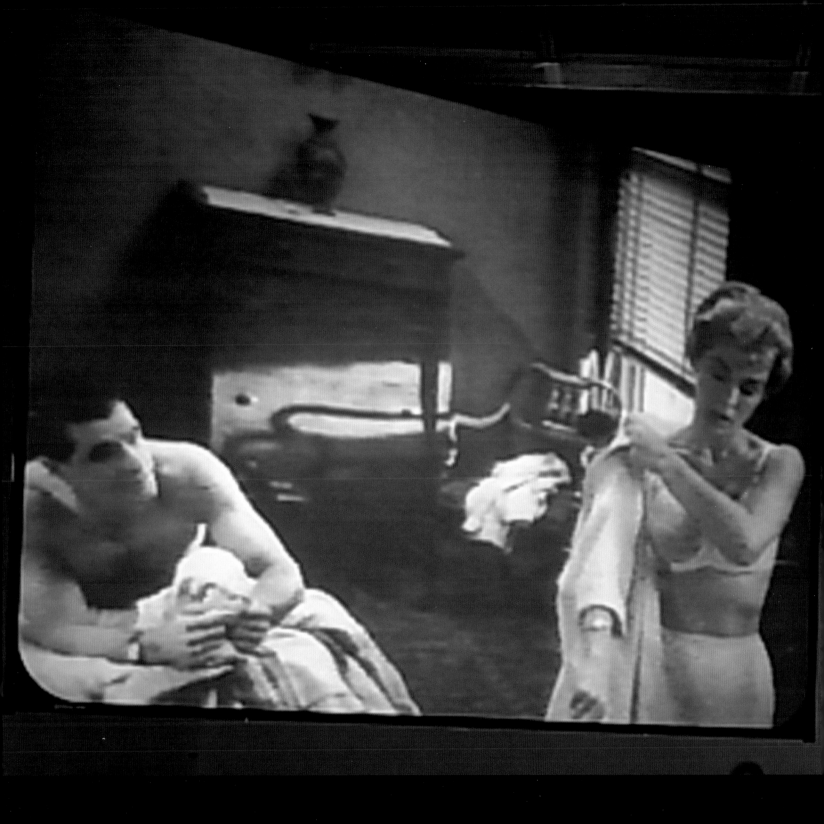

Stills from **24 Hour Psycho**, 1993
Video installation
Dimensions variable

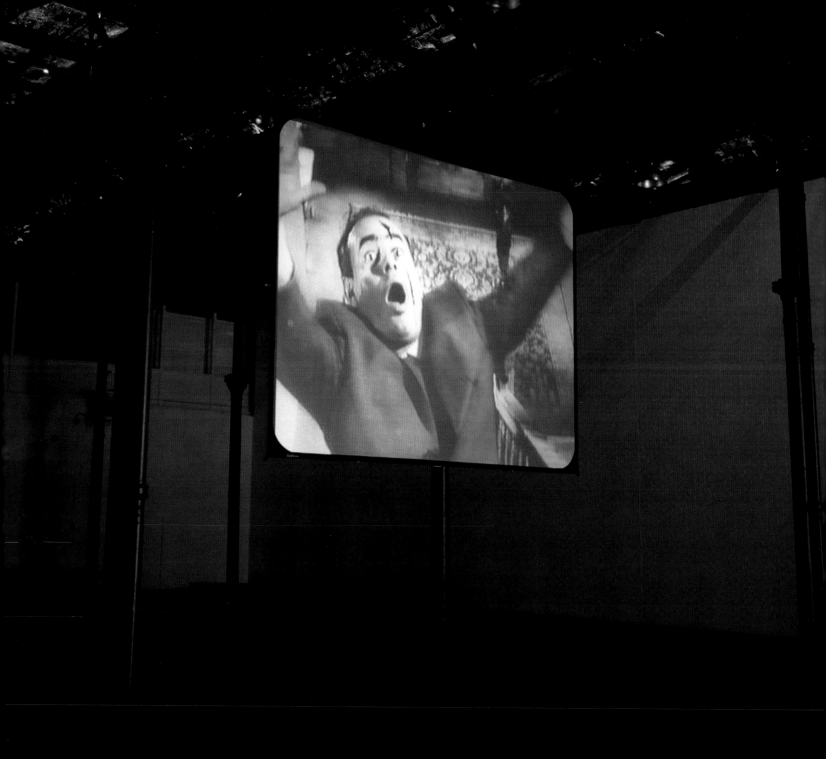

as presence. As the contemporary Scottish novelist James Kelman has written, "The most crucial aspect of James Hogg's achievement is linked to this 'present-time consciousness' and the way in which he succeeded in embellishing himself in the text. Any attempt to isolate him from the 'reality' of his 'fiction' leaves the reader stranded in strange loops and warps."[6]

The central narrative of Hogg's novel is framed by another text, "The Editor's Narrative," which attempts to persuade us of the authenticity of the main text as a found document dug up from the protagonist's grave. "I have now the pleasure of presenting my readers with an original document of a most singular nature," Hogg writes in his guise as "The Editor," "I offer no remarks on it, and make as few additions to it, leaving everyone to judge for himself."[7] Trust me; what I present here is the simple truth. In fact, every word is a fabrication by the author.

Like Hogg, Gordon is constantly implicated in his own work. His exhibition catalogues are full of supposedly explanatory texts supplied by "a friend"[8] or as "a statement on the artist's behalf" attributed to his brother, David. Perhaps David Gordon did indeed write that text about his brother, but towards the end he notes that "now I'm sounding just like him, so I should start to stop."[9] The text itself appears between reproductions of *Confessions of a Justified Sinner* (1995/96) and *Tattoo (for Reflection)* (1997). Starting to stop. But not stopping starting. Prologues become epilogues, books start from the back and proceed to the front. Splittings and reversals are among the few constants in a body of work that constantly takes on new forms. His own body is simultaneously the site of constant alteration and the place where certain things become fixed. His "Trust Me" tattoo is a work of art in the photographs *Tattoo (I)* and *Tattoo (II)* (both 1994), but it is also a permanent inscription on his left arm. The gap between

the two states is treacherous ground, where viewers may indeed find themselves caught in "strange loops and warps."

Sometimes the loop can lead all the way back to Gordon's own conception and birth. *Something between my mouth and your ear* (1994) seems at first to be austerely minimal and quite impersonal. An entire room is painted blue. Some stereo equipment plays old pop songs. All the songs however turn out to be hits from January to September 1966: the precise period during which Gordon was in his mother's womb. The neutral room becomes suddenly visceral, and we feel ourselves almost floating alongside an as-yet-unborn Douglas Gordon. Our own recollections or associations with these songs become fused with Gordon's implicit claim to have been conscious even then (at least of the good songs). The title makes an explicit, almost sexual, connection between Gordon as the work's author and the audience as its recipient, yet in the end the work locates itself somewhere in between. Reminiscent of the extended opening of Laurence Sterne's *The Life and Opinions of Tristram Shandy, Gentleman* (1759–61), this work seems to suggest that a return to the womb is inescapable, and the departure from it perhaps undesirable. Even if "we gotta get outta this place," we are also "homeward bound." In either case, Gordon succeeds in entrapping his audience in the space between his own life and the work of art. He is able to use an unambiguously autobiographical strategy that at the same time taps into a widely shared set of cultural references. The all but inevitable associations that his audience has with these well-known songs become integral to the reception of the piece, creating a shared frame of reference that is at the same time intimately specific to Gordon himself.

The particular realism of Gordon's reference to his own birth here is the other side of pieces such as *A Souvenir of Non-Existence*

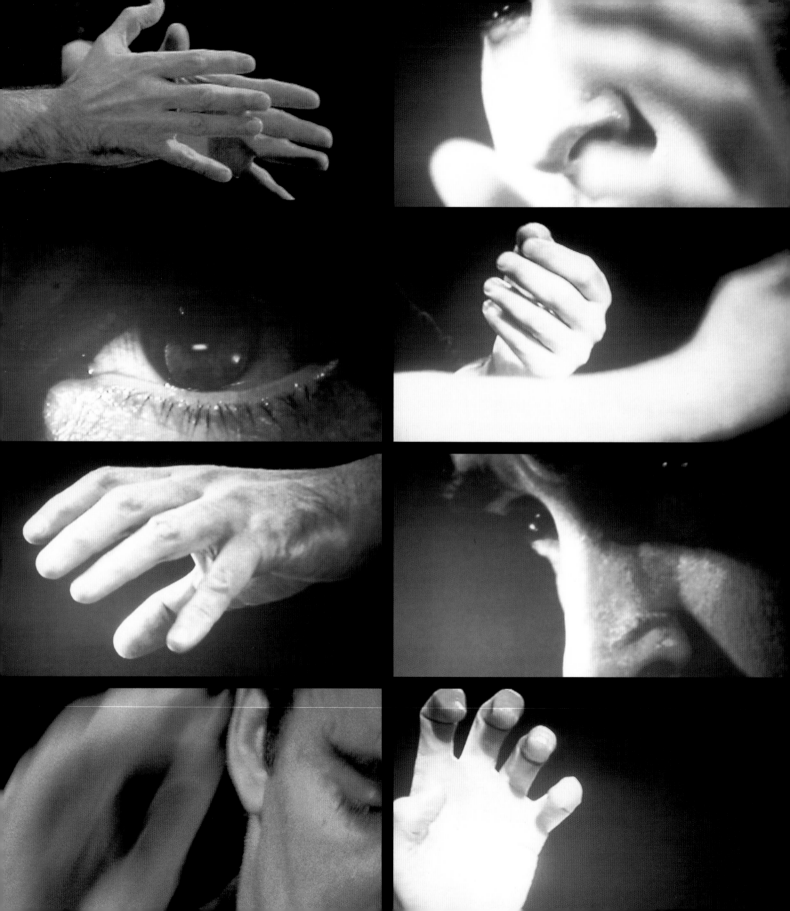

(1993), a letter from the artist addressed to the killer in Hitchcock's *Rear Window* (1954), returned as undeliverable. Gordon weaves himself into the warps of Hitchcock, blurring fiction and reality. The process can be contagious. In *Feature Film* (1999), Gordon fills the screen with James Conlon conducting Bernard Herrmann's score to *Vertigo* (1958). Our recollection of the original movie fills our imaginations as we look at Conlon's face and hands.[10]

The fresh flesh that emerged from the womb in 1966 has become a palimpsest of tattoos, one message after another inscribed across its surface: "Trust Me"..."forever"..."every day." Each new word seems like an act of resistance to passing time, and all that it will bring. In the *croque-morts* series from 2000, Gordon looked again at babies, but photographed them gnawing on their own toes. Biting the toe of a corpse is a traditional practice of French undertakers to make sure that someone is really dead. This is the other side of Gordon's insistence on his own fetal awareness. The newborn babies in this work are apparently as conscious of their death as of their birth.

In the video *A Divided Self I and II* (1996) we see two arms — one smooth, one hairy — fighting each other for dominance. Both belong to Gordon. Does this struggle for control of the self seem familiar?

> ... my eyes fell upon my hand. Now the hand of Henry Jekyll ...
> was professional in shape and size: it was large, firm, white
> and comely. But the hand which I now saw, clearly enough, in
> the yellow light of a mid-London morning, lying half shut on the
> bedclothes, was lean, corded, knuckly, of a dusky pallor and

Stills from **Feature Film**, 1999
35-mm film
Dimensions variable

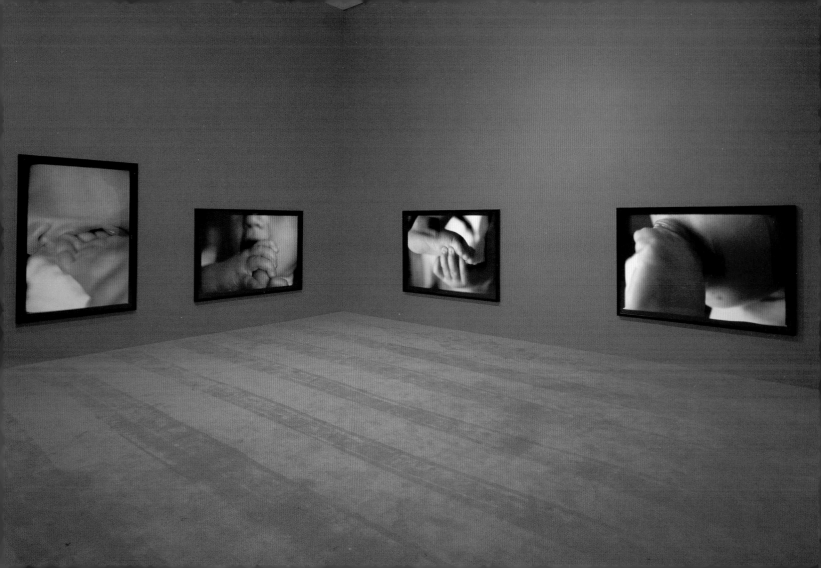

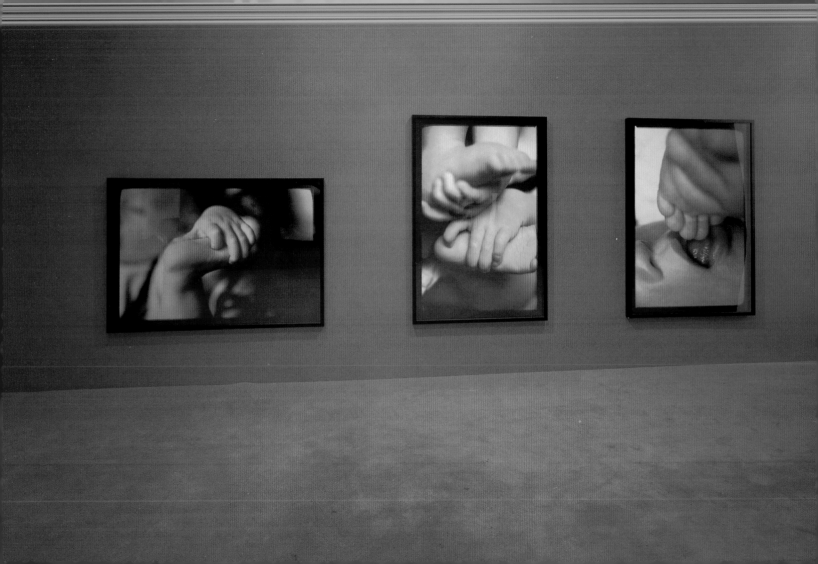

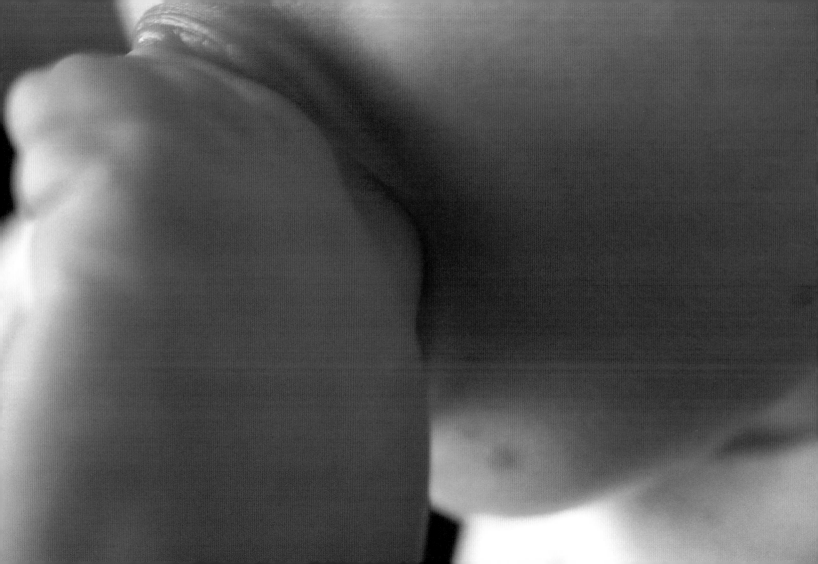

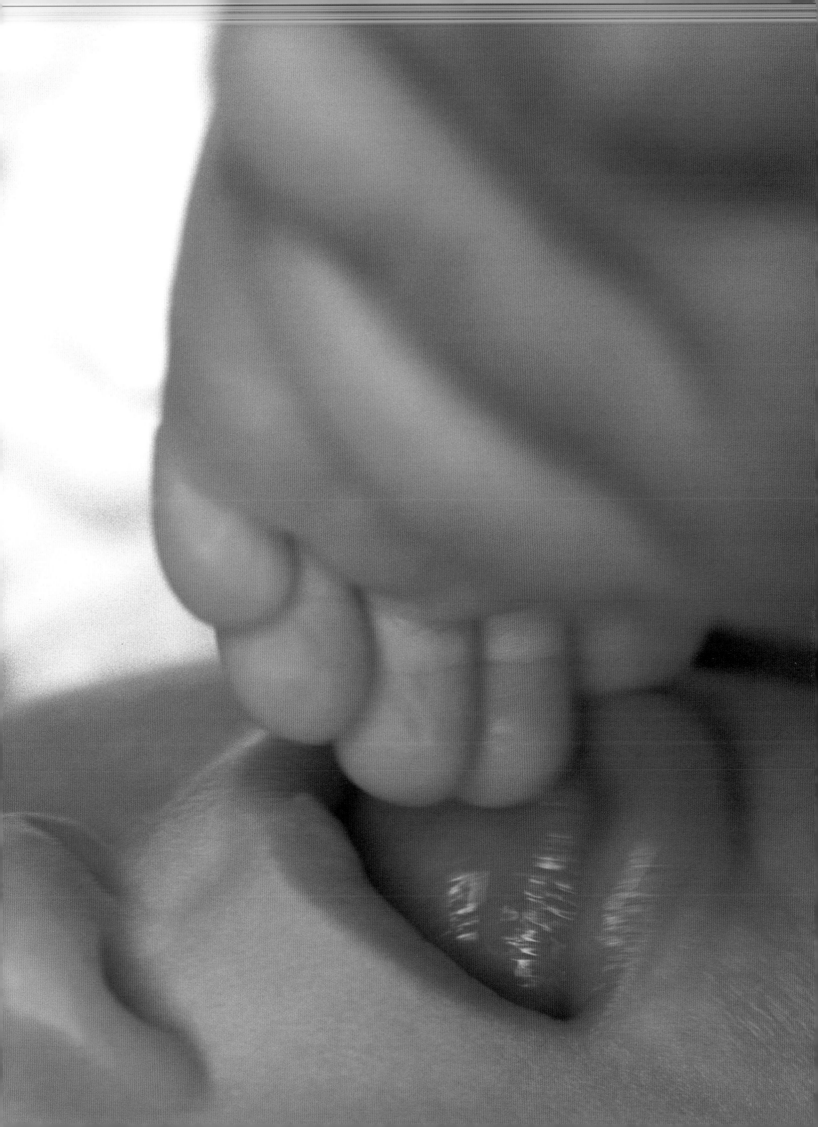

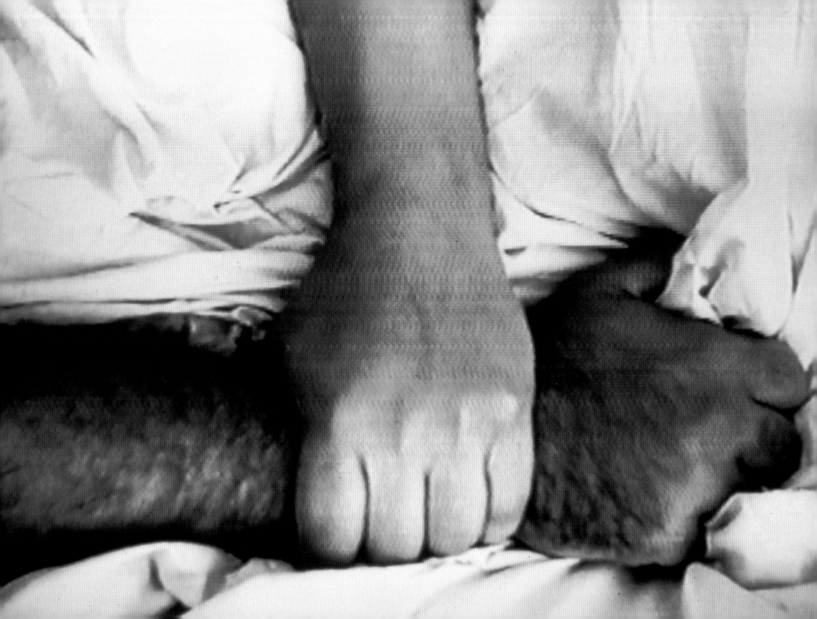

thickly shaded with a swart growth of hair. It was the hand of
Edward Hyde.[11]

Again we find ourselves sliding into the gap between fiction
and reality. Robert Louis Stevenson's *The Strange Case of Dr. Jekyll
and Mr. Hyde* (1886) follows Hogg's *Confessions of a Justified Sinner*
by about sixty years, and continues a peculiarly Scottish fascina-
tion with doubling, and double identity in particular. Gordon has
combined the two novels in his own *Confessions of a Justified
Sinner*, which attaches Hogg's title to the transformation scene
from Rouben Mamoulian's Hollywood version of *Dr. Jekyll and
Mr. Hyde* (1932). As Fredric March slowly changes from Dr. Jekyll
to Mr. Hyde, Gordon shows us the image twice, once positive
and once negative. Looping ensures that the transformation con-
tinues indefinitely, back and forth between good and evil. At
one point March's hands struggle with each other as they reach
out for his own neck, a direct precursor to Gordon's *A Divided
Self*. In these works Gordon decisively enrolls himself in the tra-
dition of split identity established by Hogg and Stevenson.

The double in the Hogg text is both the mirror image of his
narrator, Robert Wringhim, and Wringhim's opposite. "I beheld
a young man of mysterious appearance coming towards me,"
his account begins:

The discovery of the double, almost certainly a force of evil, is shot through with a powerful attraction that is undeniably sensual. One thinks of the crude gesture depicted in *Blue* (1998), in which Gordon repeatedly thrusts his index finger into the fold of his own fist.

We all see our double every day in the mirror, and mirrors are everywhere in Gordon's work. In his installations, walls of mirror disorient the viewer and add further layers of doubling to work that is already dividing itself at every turn. His own arms are now a kind of mirror, as "forever" on one forearm reflects its own image on the other. In the photograph *Tattoo (for Reflection)*, the word "Guilty" can be seen tattooed in reverse on the writer Oscar van den Boogaard's left shoulder. Only when he takes stock of himself in a mirror can van den Boogaard see his tattoo, and when he does it speaks directly to him, not in reverse. The verdict it suggests is always, remorselessly, the same: guilty as charged. "For Reflection," of course, has a double meaning. The reflective surface of the mirror becomes symbolic of an inward-looking self-examination even as it maintains its more literal meaning. "Listen, Oscar," Gordon told van den Boogaard the day before the tattoo was inscribed, "when you do your tattoo, you have to think about the worst thing you've ever done. It's like a catharsis."[13] The catharsis consists in the realization that the worst thing is also a part of you.

"I concealed my pleasures," Dr. Jekyll writes through Stevenson, but "when I reached years of reflection ... I stood already committed to a profound duplicity of life." Jekyll's reflection reveals to him that his evil, pleasure-seeking self is not something that can be kept to one side and released selectively. It is an integral part of him. "I was driven to reflect deeply," he continues. "Though so profound a double-dealer, I was in no sense a hypocrite; both sides of me were in dead earnest."[14] Gordon is himself in a sense

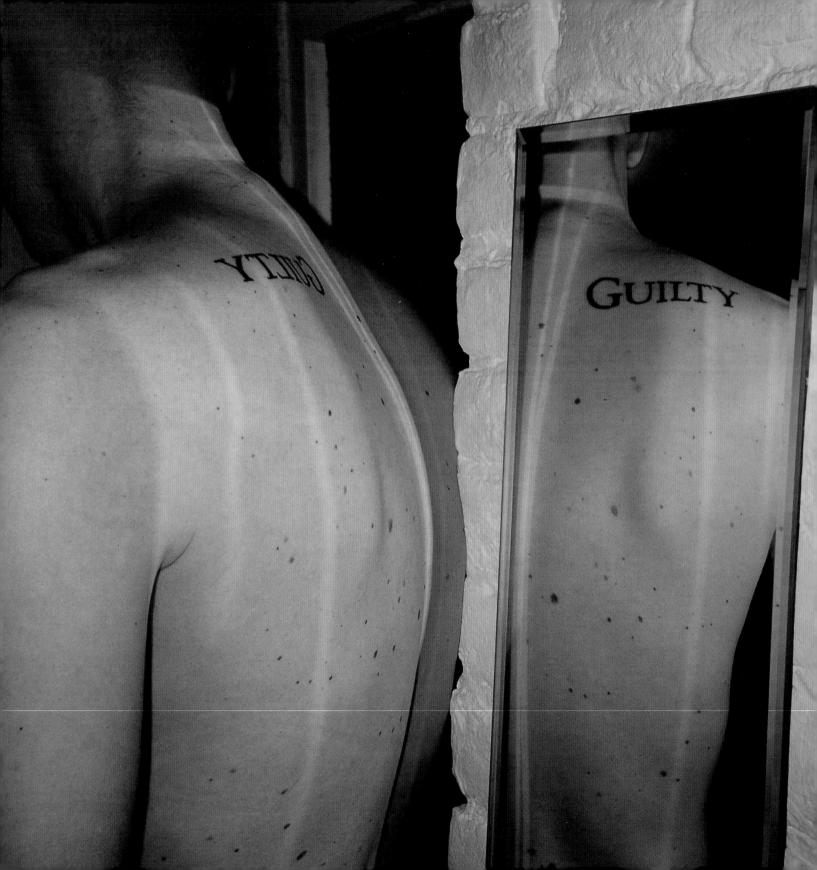

a double-dealer of this kind. In no way a hypocrite, he loves never-theless to explore both sides, to probe his own alternative identities by means of reversals and reflections. "I like the idea that when you don't do anything wrong during the day, and then look in the mirror before going to bed, you see your guilty alter-ego. That can be satisfying, right?" he pressed van den Boogaard. "But it's just as nice when you know you have done something wrong and can recognize your reflection in the mirror.... To look in the mirror for the first time, see your own reflection, and that reflection shows your guilt ... I wish I were getting the tattoo myself."[15]

The mirror is the tempting doorway to doubleness, and to every-thing dark and uncanny that civilization enjoins us to suppress. Think of Sigmund Freud in his railroad sleeping car, surprised by the sudden entrance of a stranger: "I at once realized to my dis-may that the intruder was nothing but my own reflection in the looking-glass of the open door. I can still recollect that I thoroughly disliked his appearance."[16] The double is the double of ourselves. Even if we might prefer at first not to acknowledge it, the eventual thrill of recognition is inescapable. Consider Dr. Jekyll, staring into his mirror, the face of Mr. Hyde staring back at him: "I was conscious of no repugnance, rather of a leap of welcome. This, too, was myself. It seemed natural and human. In my eyes it bore a livelier image of the spirit, it seemed more express and single, than the imperfect and divided countenance I had been hitherto accustomed to call mine."[17] The conventional relationship between the unitary self and the double is here called into question. Perhaps it is the everyday self that is irredeemably locked into division, the constant internal struggle between good intentions and base desires.

Why is it that the tradition of (possibly satanic) double identity has had such purchase on the Scottish consciousness? "It would

Tattoo (for Reflection), 1997
C-print
22½ × 23¼ inches

be very disappointing," Gordon has observed, "if the devil existed but God didn't."[18] Clearly, though, the possibility has occurred to him. "It has an intensely Scottish flavour," the English author John Wain wrote of *Confessions of a Justified Sinner*, adding that "its characters exhibit a psychology and a motivation very rarely to be met with among the English."[19] The theme of a self-consciousness profoundly divided is characteristic of cultures on the periphery of the dominant. "A minor literature doesn't come from a minor language," Gilles Deleuze and Félix Guattari wrote. "It is rather that which a minority constructs within a major language."[20] Deleuze and Guattari were thinking primarily of Franz Kafka's writing in German, but their definition is equally applicable to Scots writing in English. Dr. Jekyll's transformation into Mr. Hyde can easily be read as a parallel to Gregor Samsa's transformation into a dung beetle in Kafka's "The Metamorphosis" (1915). James Kelman's novel, *How Late it Was, How Late* (1994), written in a distinctively Glaswegian English, begins with the main character, Sammy, awakening after a series of drinking binges blind and with large parts of his short-term memory completely missing, time lost to himself. "Ye wake in a corner and stay there hoping yer body will disappear, the thoughts smothering ye; these thoughts; but ye want to remember and face up to things, just something keeps ye from doing it, why can ye no do it; the words filling yer head."[21] Both the double identity and this floundering in time and memory are constantly recurring themes in Gordon's work.

For Gordon, memory is always moving backwards and forwards, playing out sequences of repetition and desire that promise wholeness even as they flirt with fragmentation and death. The soundtrack to *Something between my mouth and your ear* repeats endlessly, as the artist explores the primal fantasy of return to the womb. In *24 Hour Psycho* there is a constant tension between

our memories of the film, its plot and its resolution, and our expe-
rience of Gordon's endlessly stretched-out version of it. The effect
of this work does not depend entirely, however, upon our past
memories of the film. It is equally invested in what might be called
future memories, recollections of things yet to come. In the account
supposedly given to his brother, David, Gordon describes how
this might work. He invokes a hypothetical viewer who might have
stopped by an exhibition space and spent some time looking at
the work:

> He went on to imagine that this "someone" might suddenly remem-
> ber what they had seen earlier that day, later that night; perhaps
> at around 10 o'clock, ordering drinks in a crowded bar with friends,
> or somewhere else in the city, perhaps very late at night, just as
> the "someone" is undressing to go to bed, they may turn their head
> to the pillow and start to think about what they had seen that day.
> He said he thought it would be interesting for that "someone"
> to imagine what was happening in the gallery right then, at that
> moment in time when they have no access to the work.[22]

Of course it is precisely at such a moment that one *does* have
access to the work, at the point where it has entered the subcon-
scious, has become both a memory and a potential memory that
will recur in the future. The piece is perhaps most fully realized
when it flickers simultaneously in the memories of both the artist
and the viewer. In his ongoing project *5 Year Drive-By* (1995),
in which John Ford's *The Searchers* (1956) is intended to be
projected with unbearable slowness over the five years taken up
by the film's narrative, the role of the viewer's memory is, if any-
thing, even more central. While the piece has been shown in
partial form for periods of a few days, it has not been projected

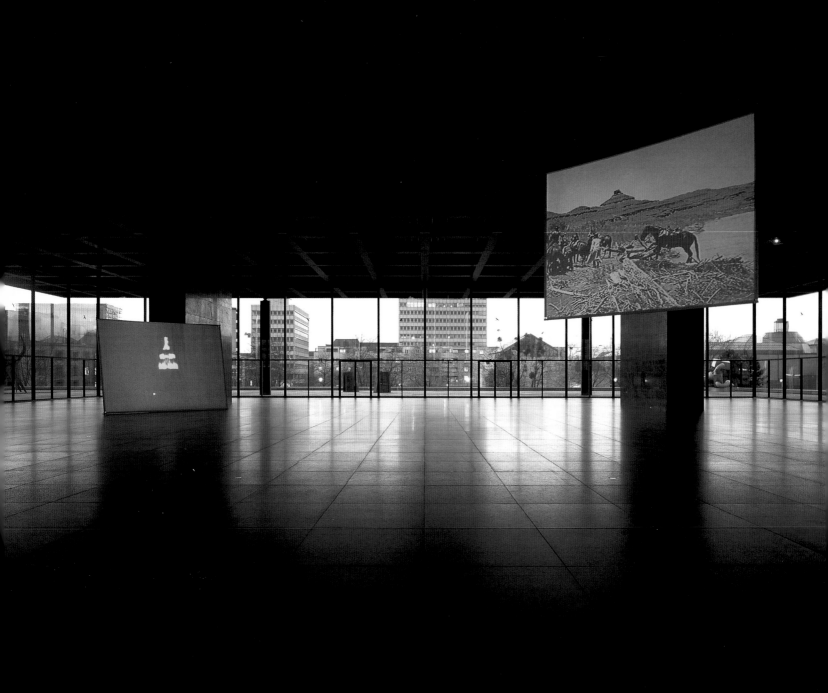

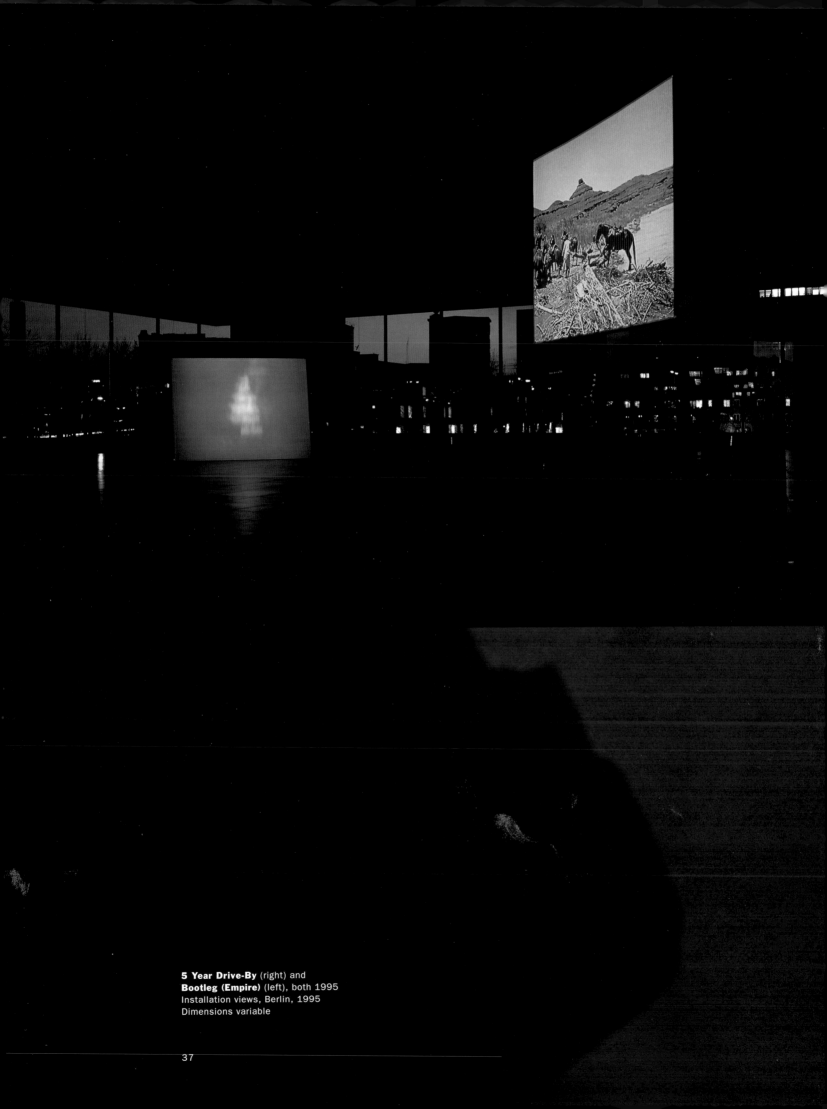

5 Year Drive-By (right) and
Bootleg (Empire) (left), both 1995
Installation views, Berlin, 1995
Dimensions variable

in its entirety. Even if it were to be shown from beginning to end, however, on any given encounter viewers would never see more than a few frames of Ford's film, since each individual frame would be visible for approximately fifteen minutes.

His text pieces are likewise intended to generate their effect not so much at the moment a viewer initially experiences the work, but at an uncertain future point. One instruction text reads: "From the moment you read these words, until you meet someone with blue eyes." The word "until" positions the piece unequivocally in the future, but its fundamental structure remains rooted in memory. A typical recipient of the text will register the words, but then move on to other things. At some later point, however, a particular pair of blue eyes may recall the work. If it does, then Gordon has succeeded in inducing a highly personal, yet involuntary, memory for a stranger. However, as usual in Gordon's work, a certain dichotomy is involved because the piece is as much about forgetting as it is about remembering. Many viewers will forget the text instantly and never recall it. Others will remember it only after a period of forgetting, during which they may have met several people with blue eyes.

At first it may seem as if this movement back and forth between the past and the future, between memory and forgetting, is simply another variation of the Manichean reversals found throughout Gordon's work. In fact, however, it is the play of memory that seems to offer the only potential escape out of the otherwise constant oscillation between opposites. Memory has been central to Gordon's work from the beginning. His *List of Names* (1990–ongoing), for example, is a heroic effort to remember everyone he has ever met, a work that Thomas Lawson has astutely called "terrifyingly simple."[23] The seemingly endless specificity of identity in the list of names exists as a counterpart to the desperate dualism that

marks much of his other work. "It was the curse of mankind," Dr. Jekyll writes, that good and evil should co-exist, "that in the agonised womb of consciousness, these polar twins should be continuously struggling."[24] But in his attempts to separate the two, Jekyll understood something that is also increasingly evident in Gordon's work: that the first split may be only the beginning of a more profound fragmentation. No sooner has he written that "man is not truly one, but truly two," than Jekyll acknowledges that "Others will follow, others will outstrip me on the same lines; and I hazard the guess that man will be ultimately known for a mere polity of multifarious, incongruous and independent denizens."[25]

In *Between Darkness and Light (After William Blake)* (1997), two films, *The Song of Bernadette* (1943) and *The Exorcist* (1973), play on the same screen, projected from opposite sides. This again seems at first a simple juxtaposition of opposites, but as the two films literally mingle with each other, the combined effect is anything but polar. As the two sets of images flow in and out of each other, and as their soundtracks mingle, everything comes together in a new kind of purgatory. Angelic nuns patrol Linda Blair's house as her screams blend seamlessly with their hymns. This time, we as viewers are asked not merely to register two separated extremes, but also to acknowledge their interpenetrations. We find ourselves in between, just as in *through a looking glass* (1999) we are positioned between two images of Robert De Niro [as Travis Bickle in *Taxi Driver* (1976)] as he talks through us to his own mirror image. In both works Gordon makes use of very well-known films, as he often does, confident that our very familiarity with them will offer quick access to the somewhat different place he wants to put us.

The physical body is the place where the artist makes his stand against fragmentation ("forever"), but one suspects that it is a

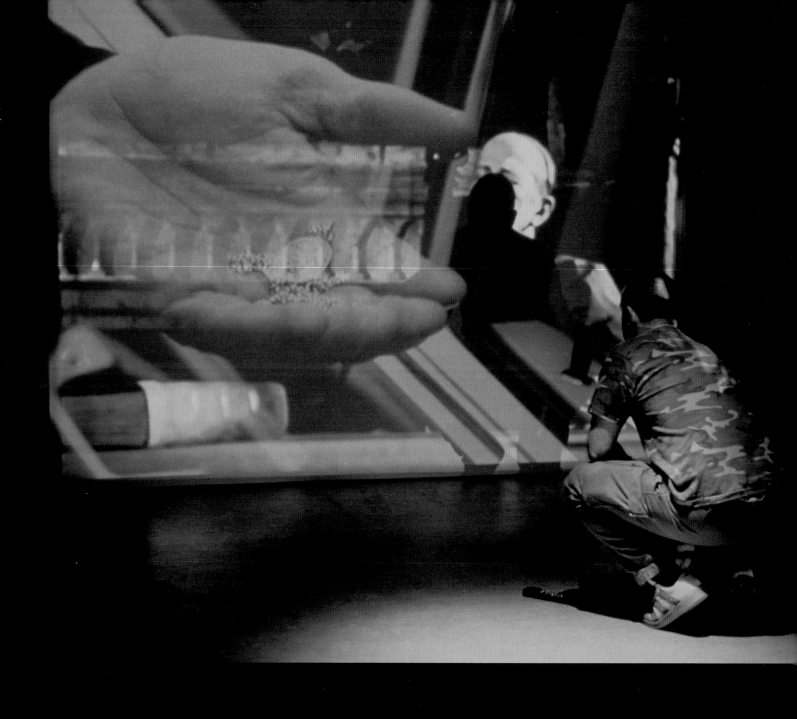

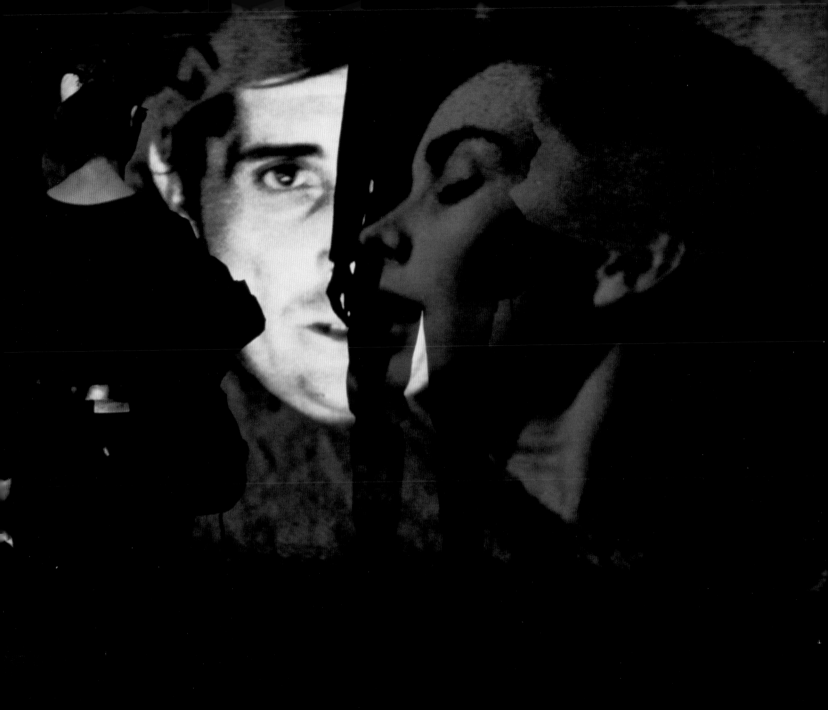

Stills from **Between Darkness and Light (After William Blake)**, 1997
Video installation
Dimensions variable

30 seconds text.

In 1905 an experiment was performed in France where a doctor tried to communicate with a condemned man's severed head immediately after the guillotine execution.

"Immediately after the decapitation, the condemned man's eyelids and lips contracted for 5 or 6 seconds...I waited a few seconds and the contractions ceased, the face relaxed, the eyelids closed half-way over the eyeballs so that only the whites of the eyes were visible, exactly like dying or newly deceased people.

At that moment I shouted "Languille" in a loud voice, and I saw that his eye opened slowly and without twitching, the movements were distinct and clear, the look was not dull and empty, the eyes which were fully alive were indisputably looking at me. After a few seconds, the eyelids closed again, slowly and steadily.

I addressed him again. Once more, the eyelids were raised slowly, without contractions, and two undoubtedly alive eyes looked at me attentively with an expression even more piercing than the first time. Then the eyes shut once again. I made a third attempt. No reaction. The whole episode lasted between twenty-five and thirty seconds."

...on average, it should take between twenty-five and thirty seconds to read the above text.

Notes on the experiment between Dr. Baurieux and the criminal Languille (Montpellier, 1905) taken from the Archives d'Anthropologie Criminelle.

losing battle. In *30 Seconds Text* (1996), viewers enter a darkened room and, in a sudden thirty-second interval of illumination, are called upon to read a text describing nineteenth-century experiments to find evidence of consciousness in the newly severed head of a guillotined criminal. The work juxtaposes a fragmented (beheaded) body with its consciousness, and the time it takes to read the account is both the duration of the experiment and the period of illumination. In *Three Inches (Black)* (1997), a finger is tattooed entirely black. At the root of the piece is a story Gordon heard as a child that the police would confiscate any sharp object over three inches long, on the grounds that such an object could potentially penetrate a vital organ such as the heart. In this context the black finger becomes a permanent, stable juncture between the inside and the outside of the body, a reminder of the pulpy mass just below the skin; yet it is also potentially as rigid and sharp as a blade. The phallic overtones are unmistakable. We could think again of *Blue*, and Gordon's finger plunging into and out of his own fist, but we could also think of *Fragile hands collapse under pressure* (1999), in which a cast of Gordon's hand sits crystallized in a vitrine, two of the fingers damaged by the compression inherent in making the work.

In the video *10ms⁻¹* (1994), a man is trying to stand up, but some powerful trauma keeps sending him crashing to the ground. It is the pressure of his memories that have left him out of control. He can no longer trust his own body. Over and over he tries to get up. Again and again he falls. Gordon's loop of this turn-of-the-century medical footage extends the cycle ad infinitum. In *Hysterical* (1994/95), another piece that uses old medical footage, a woman undergoes a hysterical fit. Again, the material is looped, continuing the crisis indefinitely. And again, we must take uncontrollable memories as the precipitating factor. "Hysterical

30 Seconds Text, 1996
Text on black wall, timing device, and lightbulb
Bembo and Helvetica typefaces

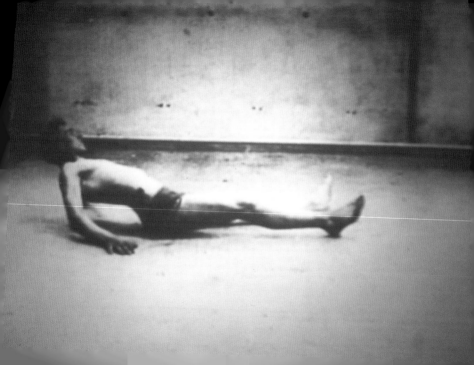

patients," Freud wrote in one of his earliest texts, "suffer princi-
pally from reminiscences."[26] In *Trigger Finger* (1994), we see
only a twitching index finger, doomed forever to pull the trigger
of an absent gun. The repetitive twitching is profoundly physical,
yet at the same time it suggests the "involuntary memory" so
important to Henri Bergson's thought. In the series of *Film Noir*
videos from 1995, everything is reduced to such tightly and
obsessively observed details.

In 1999 Gordon suffered a fall on a street in Brooklyn, the
details of which he cannot recall. The following year he began
a series of photographic self-portraits that focus on the small
scar above his left eye that resulted from the accident. Taken
on consecutive days during the course of an exhibition in Paris,
the photographs adhere to the same format, but have individual
titles. Collectively, they are called *Punishment Exercises*. Here
the oscillation between positive and negative so evident else-
where in Gordon's work has been replaced by a relentless pattern
of repetition. Repetition is a mode established in Gordon's earlier
work, especially in the looping of his videos; however, prior to
Punishment Exercises, it had been evident nowhere more than in
the audio installation *What You Want Me to Say* (1998), in which
a broken record of Gordon's voice repeating the words "I love
you" plays endlessly. "Repetition is an absence of direction," the
film theorist Stephen Heath has written. "The return to the
same in order to abolish the difficult time of desire, it produces
in that very moment the resurgence of inescapable difference,
produces indeed the poles of 'same' and 'different'; its edge, its
final horizon, is thus death, the ultimate collapse of same
and different."[27]

In *Déjà vu* (2000), Gordon brought together in a single work
a number of the themes that have increasingly dominated his

work, most notably memory, repetition, and death. Once again, he used the accessible vocabulary of the Hollywood film as his vehicle. *Déjà vu* is a triple projection of the film noir *D.O.A.* (1950). The film begins with a man entering a police station to report a murder: his own. He has been given a slow-acting but irreversible poison that is about to kill him. His last few hours are devoted to piecing together the events that will lead up to his death, and most of the film consists, therefore, of extended flashbacks. In Gordon's version, the central projection shows the film at the normal speed of twenty-four frames per second, while those on either side of it proceed at twenty-three frames per second and twenty-five frames per second. The three projections thus begin in synchronization but increasingly separate from each other as the narrative advances. Our attention moves back and forth as images that are already flashbacks repeat themselves again. Gordon's installation succeeds in conflating the past, present, and future, as the hapless protagonist attempts to recover his memory. In the end, however, his memory can reveal to him only the circumstances of his own murder. Everything that has come apart may in the end resolve itself, but only in death.

In 1993, Gordon made an installation called *Trust Me*, in which a performer walked a tightrope stretched high across the exhibition space. There was no safety net. Trust has remained a touchstone in his work ever since. "I can't tell you what the worst thing I have ever done is," he said to Oscar van den Boogaard, but "what's bad," he continued, "is to break trust with someone. That's the worst thing you can do if you do it intentionally."[28] But, as van den Boogaard himself wrote, "Everything in Douglas Gordon's world is true and untrue at the same time."[29] Can he be trusted? Or will he suddenly reveal the black spot, a symbol of imminent death in Stevenson's *Treasure Island* (1883)?

Previous page
Film Noir (Fly), 1995
Video installation
Dimensions variable

Déjà vu, 2000
Triple video projection
Dimensions variable

"Trust Me," says the tattoo on his left arm, a permanent appeal. We have no reason not to trust him, except for the phrase itself, the quintessential confidence man's set up, paradoxically guaranteed to induce distrust. In one image he made of himself, Gordon has horns. In *Monster* (1996–97), his best-known self-portrait, he appears as the captive of dual personalities. But in a single blonde wig, he can also make his *Selfportait as Kurt Cobain, as Andy Warhol, as Myra Hindley, as Marilyn Monroe* (1996). As Dr. Jekyll suggested, multiple identities lie beyond the initial split, and each is as authentic or as false as any other, true and untrue. In Herman Melville's *The Confidence-Man: His Masquerade* (1857), the eponymous protagonist is none other than the devil himself, a shape-shifting, identity-altering swindler on board a Mississippi River steamboat. Like Gordon, he asks for trust: "Trust men. Just try the experiment of trusting men for this one little trip."[30] He wants his victims' confidence so that they will voluntarily give him their souls. The point of payment — the point at which everything else, including trust, becomes moot — is death.

Monster, 1996–97
Transmounted C-print
37½ × 50 inches

Selfportrait as Kurt Cobain, as Andy Warhol, as Myra Hindley, as Marilyn Monroe, 1996
C-print
30½ × 30½ inches

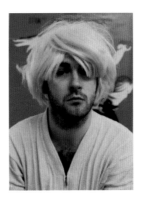

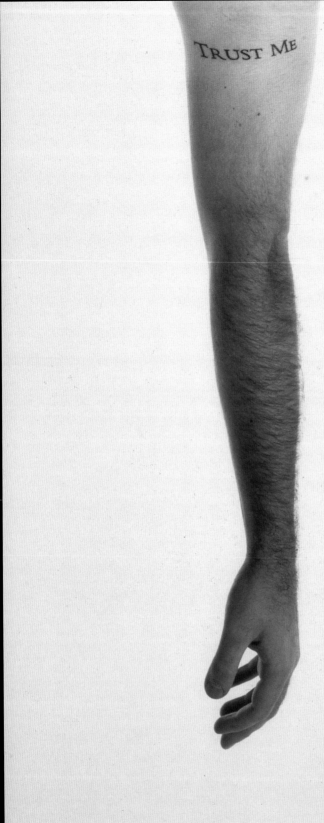

Tattoo (I), 1994
Black-and-white photograph
53 × 34¾ inches

Tattoo (II), 1994
Black-and-white photograph
53 × 34¾ inches

1. James Hogg, *The Private Memoirs and Confessions of a* reprint, London: Penguin, 1987), 181.

2. Michael Fried, "Art and Objecthood" (1967), in *Art a Reviews* (Chicago: The University of Chicago Press, :

3. Walter Benjamin, "The Work of Art in the Age of Me *Illuminations*, ed. Hannah Arendt, trans. Harry Zohn Brace & World, 1968), 240.

4. Gordon, in "Douglas Gordon" pamphlet (Wolfsburg, n.d.).

5. Fried, "Art and Objecthood," 168.

6. James Kelman, "A Reading from Noam Chomsky and the Philosophy of Common Sense," in *Edinburgh Rev*

7. Hogg, *The Private Memoirs and Confessions of a Justifi*

8. "A Short Biography," in *Douglas Gordon* (Hannover: K 1998), n.p.

9. David Gordon, "... by way of a statement on the arti *Gordon: Kidnapping* (Eindhoven, The Netherlands: St 1998), 83.

10. *Feature Film* led me to look again at Hitchcock's film surprised to realize that I had forgotten that the leac the same as my own. James Stewart plays "Scotty" F

11. Robert Louis Stevenson, *The Strange Case of Dr. Jekyl* reprint, New York: Signet, 1987), 112.

12. Hogg, *The Private Memoirs and Confessions of a Justifi*

13. "Oscar van den Boogaard talks with Douglas Gordon Gordon, *Déjà Vu: Questions & Answers*, vol. 2 (Paris: N Ville de Paris, 2000), 39.

14. Stevenson, *Dr. Jekyll and Mr. Hyde,* 103, 104.

15. "Oscar van den Boogaard talks with Douglas Gordon

16. Sigmund Freud, "The Uncanny" (1919), in *Collected Papers*, vol. IV, ed. Ernest Jones, trans. Joan Riviere (London: Hogarth Press, 1953), 402 n. l.

17. Stevenson, *Dr. Jekyll and Mr. Hyde*, 108.

18. "Oscar van den Boogaard talks with Douglas Gordon," 38.

19. John Wain, "Introduction," in Hogg, *The Private Memoirs and Confessions of a Justified Sinner*, 10.

20. Gilles Deleuze and Félix Guattari, "What Is a Minor Literature?," in *Kafka: Toward a Minor Literature* (Minneapolis: University of Minnesota Press, 1986), 16.

21. James Kelman, *How Late it Was, How Late* (New York: Norton, 1994), 1.

22. David Gordon, "... by way of a statement on the artist's behalf," 83.

23. Thomas Lawson, "Hello, It's Me" (1995), in Douglas Gordon, *Déjà Vu: Questions & Answers 1992–1996*, vol. 1 (Paris: Musée d'Art Moderne de la Ville de Paris, 2000), 57.

24. Stevenson, *Dr. Jekyll and Mr. Hyde*, 105.

25. Ibid., 104.

26. Sigmund Freud and Josef Breuer, "On the Psychical Mechanism of Hysterical Phenomena" (1893), in *Early Psychoanalytical Writings*, ed. Philip Rieff (New York: Collier, 1963), 40.

27. Stephen Heath, "Film Performance," in *Questions of Cinema* (Bloomington: Indiana University Press, 1981), 124.

28. "Oscar van den Boogaard talks with Douglas Gordon," 39.

29. Ibid., 38.

30. Herman Melville, *The Confidence-Man: His Masquerade* (1857; reprint, New York: Norton, 1971), 197.

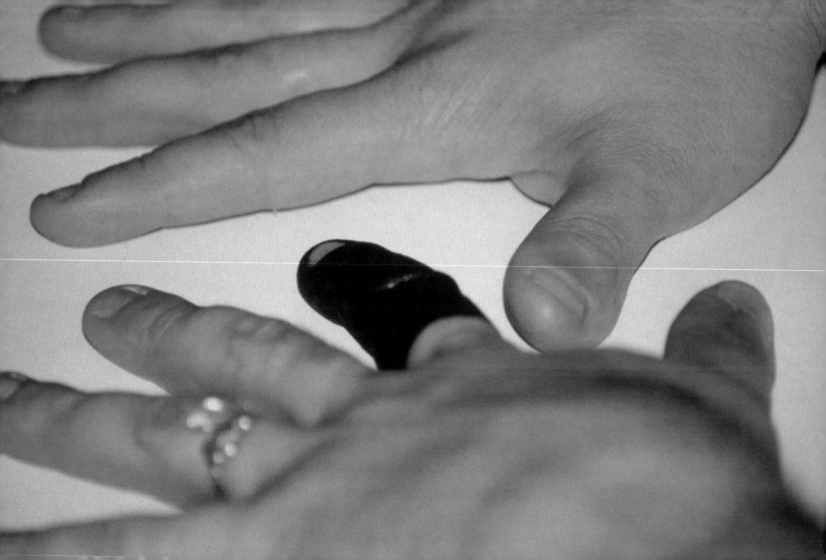

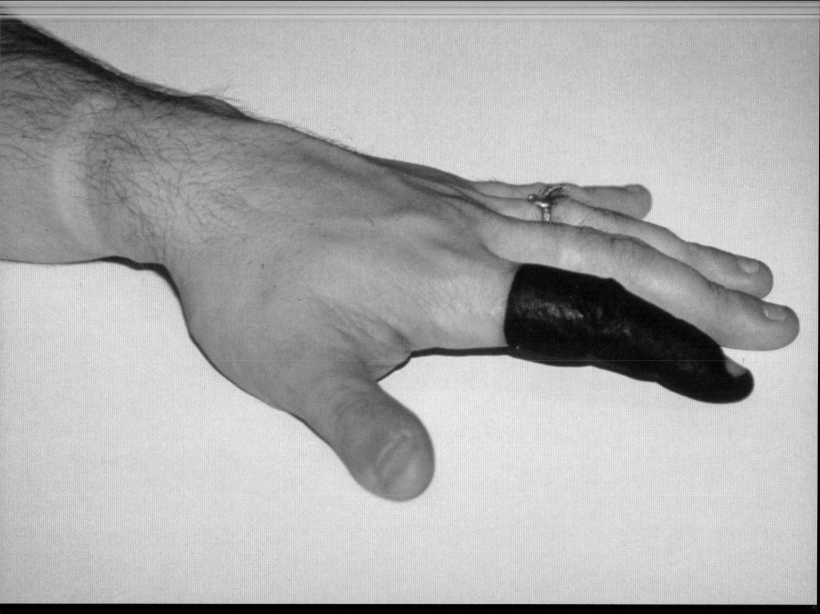

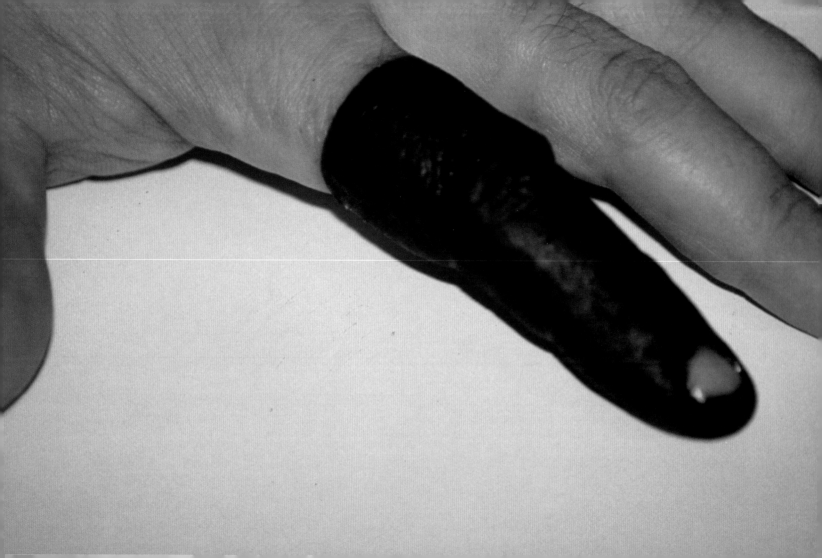

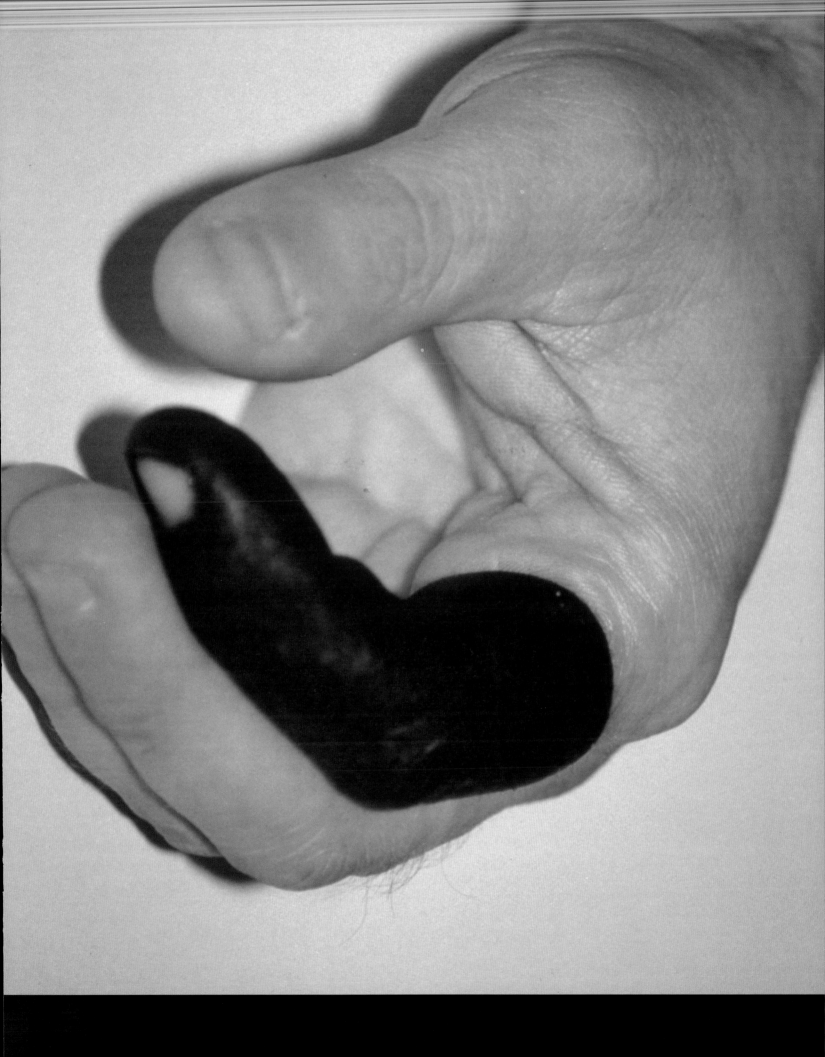

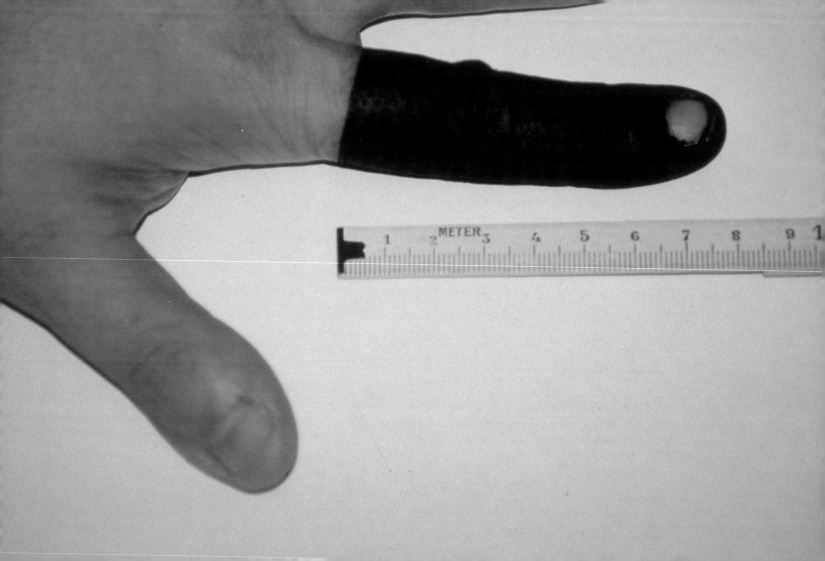

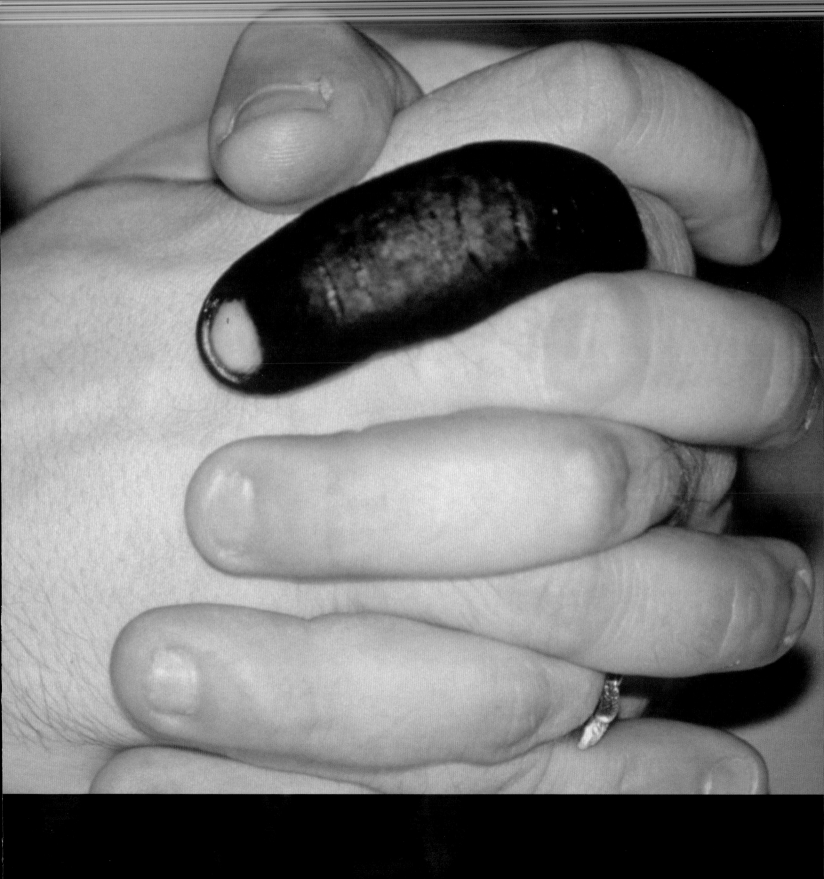

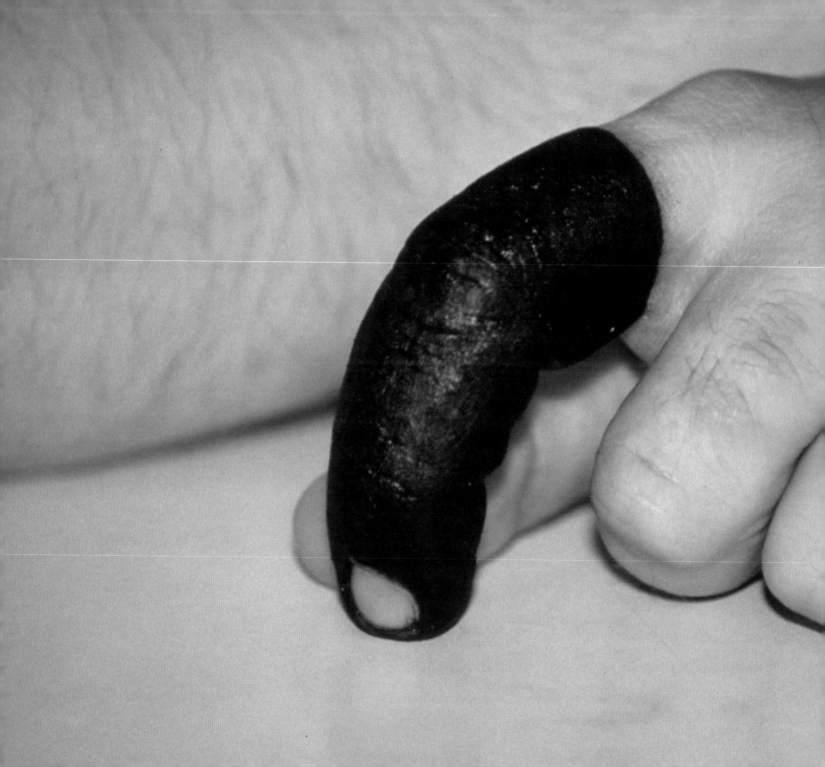

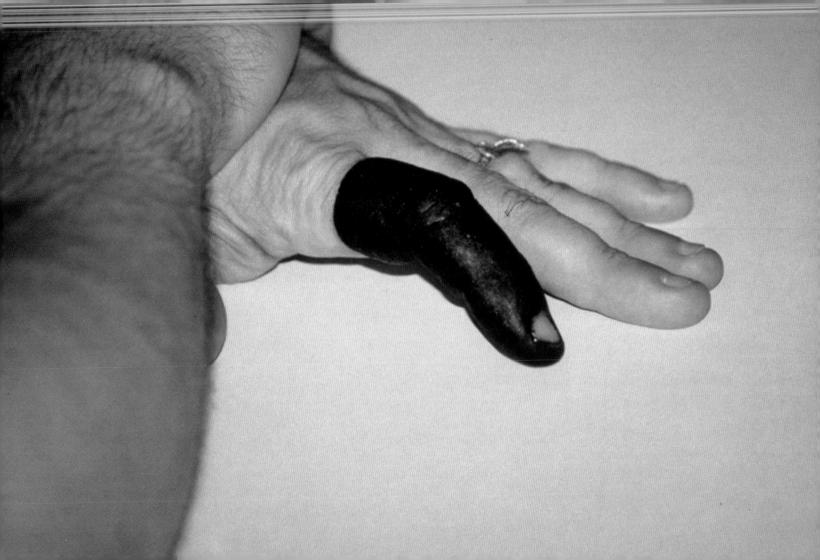

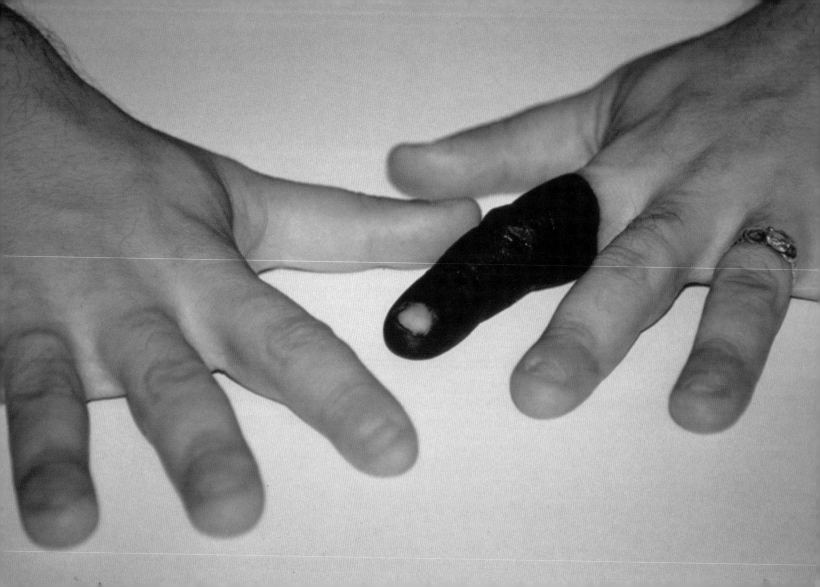

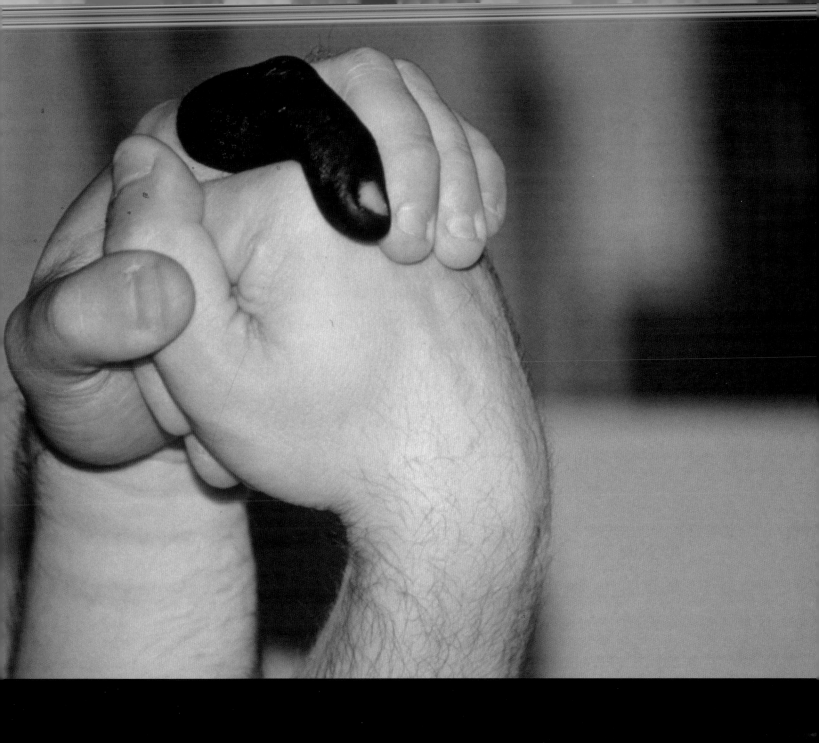

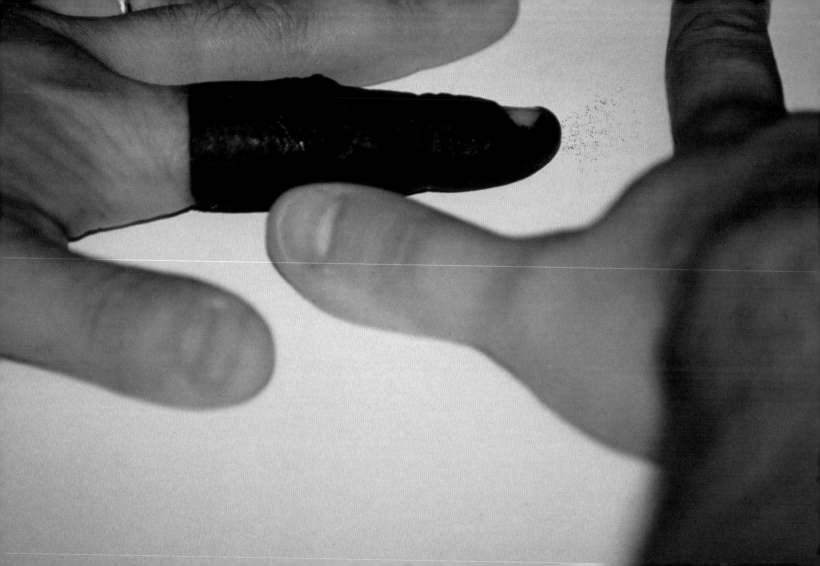

LOVE TRIANGULATIONS
BY MICHAEL DARLING

Douglas Gordon's work rigorously and intelligently tackles the
issues that have defined the art of our time. Through video,
film, photography, and text he has wrestled with the complexities
of representation, raised questions of authorship, exposed the
vagaries of memory and perception, and examined the pull
of popular culture. While hordes of artists have explored similar
themes with varying degrees of success over the last forty-odd
years, Gordon has further enriched his inquiry with a sophisticated
strategy that causes viewers to double-back and review the inter-
pretive ground they may have just gained. In so doing, he never
allows for an easy read. The use of mirroring, an affinity for
doppelgängers, and a predilection for polar opposites complicates
the communication of a message and the creation of meaning.
To quote the artist, "I like to construct self-destructive systems, or
mechanisms, which can only lead towards a multiplicity of mean-
ings, a series of contradictory interpretations. I like a conspiracy
of circumstances that can help construct a meaning for a work, or
that can turn against it at any moment."[1]

This sort of conceptual engineering is present in such works as

JAN STEVENS
ANDREA McINDEWAR
IAIN CHRISTIE
FIONA GRIFFITH
DIETMAR ELGER
NUNO ALMEIDA
LUKE BENNET
THOMAS GLATTER
COCO KAY
THOMAS KRENS
JULIA BOLZ
THOMAS CARELL
MAURICE O'CONNELL
FRANK HYDE-ANTWI
DAVID RANKIN
SIMON EISINGER
PAUL KURANKO
LISA BILLARD
NUSCH SCHULBAUM
ANNIKA STRÖM
JUTTA EBERHARD
GÜNTHER BECKER
MARGARET ARCHBOLD
ANDRE MAGALHAES
NICOLA ATKINSON GRIFFITH
ANDREW GILCHRIST
JONATHAN CALLAN
JOÃO FERNANDES
JOCK BRECKENRIDGE
COLLIER SCHORR
JOYCE PATERSON
AUDREY SMILLIE
TIM MAGUIRE
BERNHARD PRINZ
ALYSSIA FRAMIS
HEATHER ROGERS
NORMAN ROSENTHAL
CHRISTINE VAN ASSCHE
HAYLEY TOMPKINS
TEMBA MINTJES
REBECCA WARREN
ZOE WALKER
EDWARD LAVERTY
THOMAS SCHÜTTE
GEERT SCHRIEVER
OLIVE WILSON
GARY SCOFIELD
CAROLINE WOODLEY
DAVID ELLIOT
GABRIELE SAND
KETIL NERGAARD
HEIKE HELFERT
GREGOR SCHNEIDER
EMILY BATES
ISABELLA HEUDORFF
BRIGITTE RAABE
IAIN McFADDEN
LIZA MAY POST
PAUL CHRISTIE
JOSEPH CAMPBELL

DENNIS VERMEULEN
FRANCESCO SIMETI
ANGELINE SCHERF
OLIVIER SCHULBAUM
CARL-JOHANN VALGREN
ELA STRICKERT
RAINER KLEEMANN
JAN DEBBAUT
ERIC DUYCKAERTS
MICHAEL CLARK
MAX WIGRAM
ELENA FERNANDES
MYRTLE BRECKENRIDGE
BICE CURIGER
JILL HAIG
EDUARDO PAOLOZZI
WENDY JACOB
PIERRE LEGUILLON
ADAM SQUIRES
SARAT MAHARAJ
OLAFUR ELIASSON
HARALD FRICKE
SIOBHAN LIDDELL
AMI BARAK
BERNHARD STARKMANN
TIM NIEL
EULÀLIA VALLDOSERA
JILL SILVERMAN
FRITZ SCHWEGLER
KARIN SANDER
DANIEL BUREN
AYSE ERKMEN
IAIN PIERCE
JEAN LUC PEERS
CHRISTINE HILL
SASKIA BOS
ERIC GONGRICH
JES BRINCH
MICHAEL FOOT
RAYMOND BELLOUR
LAURA SARMENTO
CHERIE BLAIR
DIRK SNAUWAERT
HUBERT NEUERBERG
LORNA SIMPSON
MARTINE BOHNE
MIRTHA CODOGNATO
ANNA HANSEN
RAIMAR STANGE
INGEBORG LÜSCHER
ROMAN MENSING
BRIGITTE CORNAND
MARTIN GOSTNER
PIERRE HUYGHE
JEREMY DELLER
RUBEN ORTES-TORRES
SHANNON SHAPIRO
BARBARA STAVINI
EVA SCHMIDT
JEAN MARC BUSTAMANTE

RICHARD DOWNES
CHRISTINE HOHENBÜCHLER
LOTHAR HEMPEL
ELLA KLASCHKA
DENNIS HOPPER
DAVID TREMLETT
MARTHA McCULLOUGH
TOM THOMPSON
ROBIN KLASSNIK
CHRIS WALLACE
RONALD SCHWARTZ
MICHAEL COHEN
FIONA BRADLEY
BARBARA ENGELBACH
NICOLAS ASTI
KIM ADAMS
STEPHEN CRAIG
ISA GENZKEN
ANNIE GRIFFIN
GAVIN TURK
MEK MAAß
JENS HAANING
MONICA SCHWITTE
BARTOMEU MARI
ANDREW DAVIES
MARK VERNON
NICHOLAS FLOCH
MARTIJN SANDERS
DOMINIC HISLOP
INGVILD GOETZ
ANDY AVINI
DIETLIND HOFFMANN
NEVILLE WAKEFIELD
PHILIP LACHENMANN
MARIANNE WALTHER
CHRISTOPH GIRARDET
NEIL BEGGS
KRISTINA TIEKE
PHILIP DODD
LOUISE NERI
MARGARET BARRON
SELMA KLEIN ESSINK
CATHERINE OPIE
ADELINE PUTTMANN
GEORG HEROLD
BRIAN PETTIT
THEO WAJON
MARIA LIND
HENRIK HÅKANSSON
CHRISTIAN MARCLAY
LOUISE HOPKINS
IAIN BELL
BILL ENGLISH
DAVID PETERS
GEORGE SPENCE
ELAINE McKAY
NUNO ALMEIDA
STEPHAN GOETZ
JOHN McGROARTY
CLAUDIA BÜTTNER

YUTAKA SONE
GISELA SEITZ
LUDWIG SEITZER
JOEP VAN LIESHOUT
ALEX RENNIE
DAVID POWELL
PETER LAND
RENÉE KOOL
LOTHAR BAUMGARTEN
JEAN BAPTISTE BRUANT
ROB VAN DE VEN
COLIN STEVENSON
MARIUS BABIAS
HELEN VAN DER MAY
CHRIS DERCON
MARENTE BLOEMHEUVEL
TACITA DEAN
JOHN GILMOUR
CAROLINE ANGUS
BETTINA FUNCKE
ALYSON BAKER
DOMENIQUE GONZALEZ FOERSTER
ALEXANDER MARIS
ALAN JERMIESON
AILEEN McGLAUGHLIN
GAEL McDOUGALL
SIMON CHAMBERS
LINDA KILLIN
KATE MOODY
JOHN CLARK
GERRY GLEASON
UTE IHLENFELD
MARLENE BOYLE
DAVID PRATT
STUART BAXTER
JAN GRAY
ELAINE THOMAS
JOHN McCROSSAN
TOM PANNELL
PAUL NEAGU
ALEXANDER JOHNSTON
CHRISTIAN PHILIP MÜLLER
NEDKO SOLAKOV
ANDREW SCOTT
FRANCIS ALLEN
KATE MORRISON
LORNA ALLEN
ANGELIKA NOLLERT
REGINA BINDER
DONALD CAMERON
RICHARD LEAROYD
PAUL DIGNAN
SUSAN WAXMAN
RICHARD CORK
MARC OVERMARS
CHRISSIE ISLES
CORINNE GROOT
PAUL ANDRIESSE
KEN HAY
EMMANUEL PERROTIN

MARK DION
ROBIN DAW
PETER MOLLER
JACK FARRELL
JANET CARDIFF
GERTRUD SANDQUIST
ADRIAN FOGARTY
JAKOB FABRICIUS
NICK DEVLIN
LINDA GRAHAM
MARY CAMERON
SUTAPA BISWAS
GRAEME PATERSON
DAMIEN DUFFY
BRIAN McEWAN
PETER SUMSION
STEVEN SNODDY
KATE HENDERSON
RON BOWEN
KAREN MURRAY
TRACY CAMPBELL
JOHN SHANKIE
OLIVIA UTRERA
PAULINE RALSTON
IAIN BEVERIDGE
GEORGE McKINTOSH
ALISON KENNEDY
CHRISTINA MACKIE
CLIO LLOYD-JACOB
ANDREW GUEST
WILLIAM CLARK
ANNE COX
GRAHAM BROWN
MICK McLEAN
DREW McALLISTER
JIM McNAUGHT
SANDY STODDART
KENNY MEECHO
FLORENCE KANE
BRYAN FERRY
WILLIAM FURLONG
SARAH LUCAS
ANNA PANK
LUC STEELS
JEM LEIGH
ANYA GALLACCIO
CLIFF BOWEN
ADRIAN O'DONNELL
TESSA JACKSON
JULIE HANNAH
TOM McKENDRICK
MARTIN TIERNEY
DOUGLAS McINDOE
ALAN McLEAN
NOAM CHOMSKY
KEN GILL
PATTY KNOX
MARY McMENEMY
ALEX CRUICKSHANKS
JÜRGEN BORCHERS

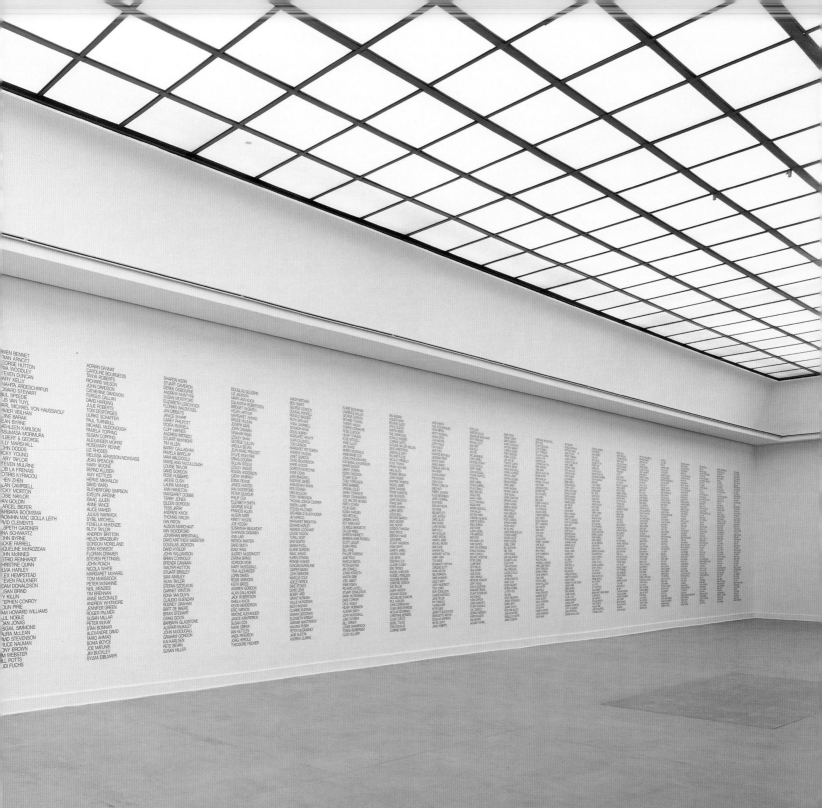

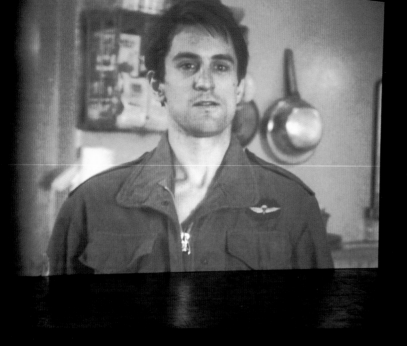

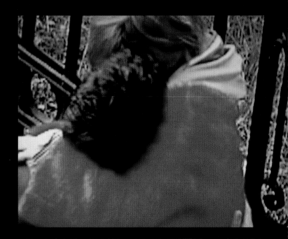

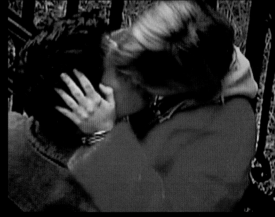

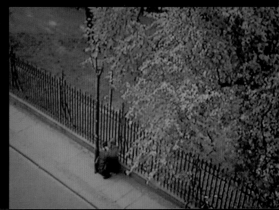

time and again. The Sisyphean logic, for instance, of *List of Names* (1990–ongoing), a constantly expanding work that records every person Gordon has met, takes a simple idea and makes it unbearable. Likewise, the maddeningly complex *through a looking glass* (1999) mirrors and doubles the famous scene from Martin Scorsese's *Taxi Driver* (1976) in which Robert De Niro's Travis Bickle looks into a mirror and repeats "You talkin' to me?" so that subject and object, image and reflection, are hopelessly confused. In such works, the viewer is trapped by the circular logic of visual and conceptual conundra that inspires reflection, contemplation, and often exasperation.

While the problems of sensory perception, representation, and structuralist thinking generated by Gordon's work have kept critics and curators plenty busy over the past ten years, there is another important and consistent component that has gone relatively unnoticed. Coursing through works in all media is a regular incorporation of heterosexual romantic sentiment, expressions of longing, and a whole lot of kissing that one is hard-pressed to find in work by any straight peer. For an artist uninvolved with queer politics, Gordon's emphasis on relationships and love is unusual, touching, courageous, and, in the end, smart, as it ventures beyond the academically sanctioned discourse that has naturally gravitated to his work while corrupting just as absolutely the systems of meaning he seeks to build up and tear down. The thorny entanglements caused by love provide the same sort of self-destructive — or self-doubting — dynamic Gordon regularly achieves through mirroring or the use of positives and negatives, and as such are crucial to his practice. Such romantic preoccupations are obvious in some works, such as *Monument to X* (1998), a video projection that, among other things, "monumentalizes" a passionate kiss

Still from **through a looking glass**, 1999
Double video installation with sound
Dimensions variable

Stills from **Monument to X**, 1998
Video installation
Dimensions variable

in the park; but once one goes looking for hints of Gordon's softer side, they start to appear almost everywhere.

The euphoria and trauma of dating and emotional relationships has been the subject of a number of works by Gordon, but it is perhaps most explicit in a series of performances where the artist kissed people (and himself) with so-called truth drugs applied to his lips. The slide projections resulting from these actions — *Kissing with Sodium Pentothal* (1994), *Self-portrait (Kissing with Scopolamine)* (1994), and *Kissing with Amobarbital* (1995) — are presented as negatives, heightening the electric moments they capture. The impulse behind the work hints at a desire to know the truth about one's lover and/or a hope that the revelation of a true story will lead to certainty and stability in an otherwise anxiety-ridden relationship. The actions have a decidedly untoward element to them in administering drugs to unsuspecting victims, but also a concomitant dose of absurdity. Gordon self-deprecatingly plays with the role of the romantic misfit in these works. After all, one doubts that the desired effects of this scheme will truly manifest themselves. The self-portrait in the group reverses the terms of inquiry, however, intimating that it might be he, as much as his lover, who has been guilty of lies. In these works and many others, Gordon points the finger both ways to emphasize the often-indistinguishable positions of accuser and accused, victim and victimizer.

Gordon's text works betray this sensibility just as readily, as they are suffused with the language of longing and unrequited love. *A few words on the nature of relationships* (1996), for instance, reads: "Close your eyes, open your mouth." Read in an art context, it can be seen as a call to iconoclasm, denying the visual experience, but it is also an unmistakably sensual utterance, lifted from the realm of pillow talk. Other text pieces

Kissing with Amobarbital, 1995
35-mm slide-projection sequence
Dimensions variable

Kissing with Sodium Pentothal (detail), 1994
35-mm slide-projection sequence
Dimensions variable

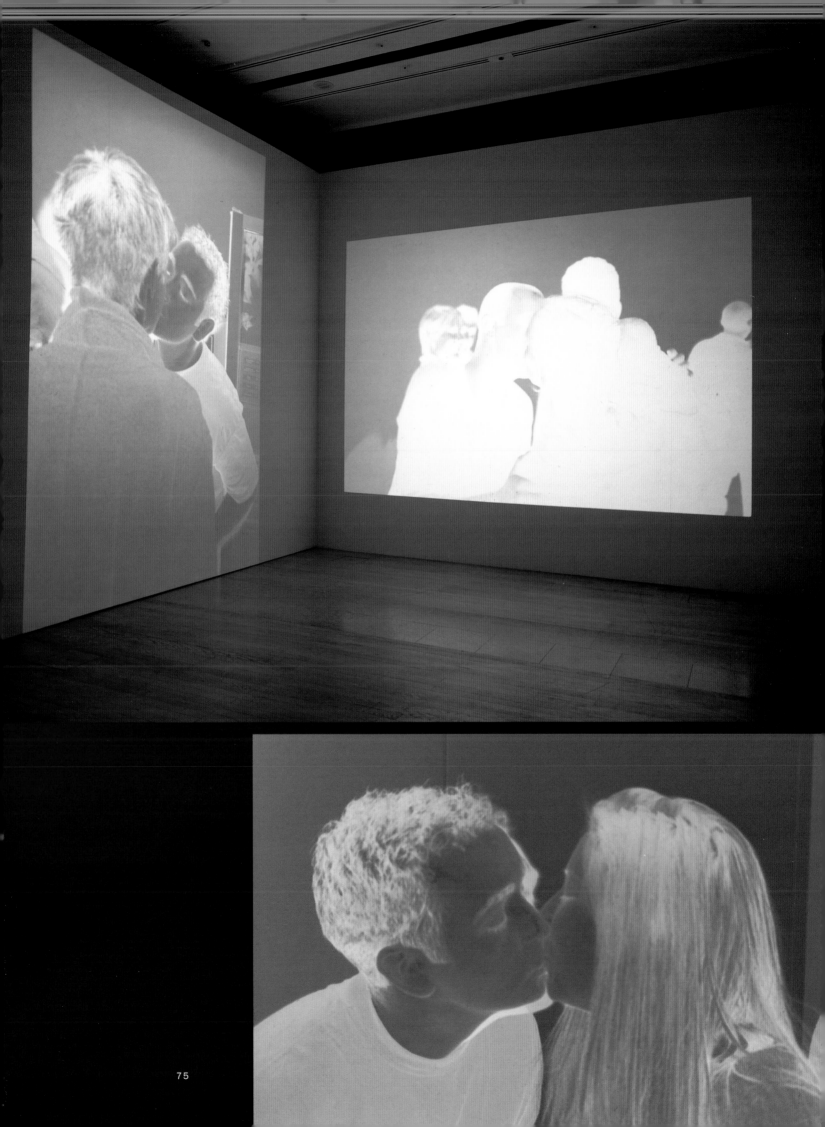

A few words on the nature of relationships, 1996

Close your eyes, open your mouth.

take the form of games, such as the work *Instruction (Number 3b)* (1993) in which a museum curator is instructed to dial a fellow employee and utter the phrase "From the moment you hear these words, until you kiss someone with green eyes." No other interchange should occur, leaving the cryptic, if titillating words to resonate in the ear and mind. Related instruction works for which the artist similarly instructed gallery owners or curators during the course of an exhibition to place anonymous calls and read brief texts without further dialogue combine to form fragments from love letters:

> Someone is listening.
> It's only just begun.
> I won't breathe a word (to anyone).
> I believe in miracles.
> I know what you are thinking.
> You can't hide your love forever.
> Everything is going to be alright.
> The simple things you see are all complicated.
> Nothing will ever be the same.

When read as a group, these texts collectively suggest the contours of an emotional give-and-take between lovers, or the painful evolution of a relationship filled with betrayal, forgiveness, and residual psychic scars. In isolation, however, the texts are also ambiguous enough to come across as threatening or paranoic. Perhaps they could be the words of a stalker, someone who is overcome with a powerful, if irrational, love for the object of obsession. In such pieces, Gordon homes in on that point where a reasonable human action or emotion is paradoxically transformed into something grotesque and

unacceptable. The works interrogate love and desire, make us confront basic human instincts, and raise the question: Can one love or care too much?

The phenomenon of the stalker, which is perhaps the contemporary embodiment of the Jekyll and Hyde story, is also referenced in *Monster* (1996–97). This photographic diptych shows the earnest, clean-cut artist on the left frame of the work, hands behind his back as if he was at the door to pick up a girl for a first date. On the right side, Gordon has transformed himself into a horrific beast, disfigured beyond recognition with strips of scotch tape. Giving visual form to parents' nightmares and tabloid stories of boyfriends gone bad, in *Monster* the artist again locates that breaking point where noble intentions become base, or the simultaneous "coexistence and coincidence of good and bad."[2]

In another body of text works, the artist sent unsolicited letters to various recipients both within and beyond the artworld. Featuring terse and oblique sentences not unlike the aforementioned spoken-word works, these pieces similarly suggest a broader narrative when viewed together:

I am aware of who you are & what you do.
From someone lost, to someone found.
Nothing can be hidden forever.
I know the place for you.
Someone is looking.
I am aware of what you have done.
I have discovered the truth.
It's better to know.
I remember more than you know.
I have not forgotten, because I cannot forget.
What have I done.

It's better not to know.
There is something you should know.
If only you were hot, or cold. But you are neither hot, nor cold.
I am going to vomit you out of my mouth.
I forgive you.

These works have been received with alternating feelings of
curiosity, invasion, and outrage, and have perhaps even jeopard-
ized future collaboration with recipients jarred by the experience.[3]
As one would come to expect from Gordon, however, these sen-
tences of course also possess double and treble meanings, often
referring to common art concepts such as viewership, revelation,
duration, completion, and authorship. The instruction works
and the letter pieces also imply the activity of a voyeur, both on
the part of the writer who is "aware of who you are & what you
do," and the non-recipient readers who feel as if they are being
given entry to some private exchange. When subsequently dis-
played as wall texts in museums or galleries, these same sentences
further contribute to a voyeuristic experience. They acknowledge
the activity of looking at art — "someone is looking" — at the same
time as they suggest the importance of people-watching in art
spaces. Indeed, Gordon has commented on the primacy of the
people-watching experience in museum-going[4] and also the impor-
tance of voyeurism in his work: "At first you take enough distance
to occupy the position of the voyeur, and then you can 'fantasize'
with the idea or the image."[5] Thus, the fragmentary nature of
Gordon's texts provides an ambiguous space in which the viewer
can project their own experiences and interpolate their own
meaning from the work. This levels the field between artist and
viewer, and, in Gordon's words, "if there's no difference between
'artist' and 'people,' then there are no barriers to art."[6]

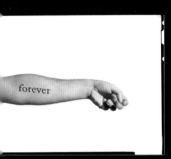

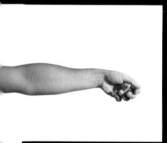

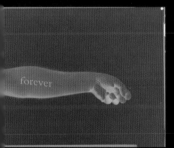

It is all the more surprising to find a romantic Douglas Gordon when one considers where he comes from: the notoriously tough streets and pubs of Glasgow. His amply tattooed body no doubt has given him the requisite amount of street cred to quell any wayward suspicions about his manliness, but a closer look at the tattoos themselves and a series of companion photo-works suggest again a sensitivity and emotional vulnerability that could get him beaten up back home. His *Tattoo (for Reflection)* (1997) is a poignant example of such duplicity. Here, the artist has made a photograph of a body double, shirtless and positioned in front of a mirror so that the word "Guilty" — which Gordon has had tattooed in reverse on the man's shoulder blade — reads correctly. When viewed through the lens of relationship dynamics, this work suggests a moment of humble introspection and/or owning up to a damaging transgression. Such transgressions, the work infers, whether they be in the form of an adulterous affair or wounding words exchanged in a heated argument, can never be erased or forgotten, just as a tattoo is a permanent stigmata. Religious meaning also emanates from the work, as it alludes to original sin and the difficulty of avoiding temptation. The vernacular toughness of the word "guilty," however, is never far from interpretation either, bestowing upon the bearer the bravura of the Glaswegian underworld, convicted of untold numbers of unspecified crimes. The fact that the faceless man is not Gordon himself, but someone of a similar body type and skin tone, makes the image even more slippery and devious, allowing the artist to forestall or evade the indictment himself.

Gordon's recent photowork *Never, Never* (2000) focuses on his polysemous bodily adornments, promulgating enticingly mixed messages. In this diptych, straightforward color photographs of the artist's forearms document the presence of a black tattoo of the

Never, Never, 2000
Two digital C-prints
24 x 30 inches

word "forever" on the left arm in one frame, and a white tattoo of the same word written backwards on the right arm. Whether backward or forward, the tattoos wittily comment on the permanence of their application. However, as with the "Guilty" tattoo, they can also be read as open-ended declarations to a romantic partner. It could express hope that his love for her will last forever, or could wistfully announce that he will remember her forever, even though the affair has ended. The black "forever," perhaps uttered while the relationship was healthy, also seems to leave a residue or imprint in the opposing, scar-like white tattoo that, despite its tenuousness, will never go away. In either case, the tattoo is a constant reminder of the couple's history, and the universality of the sentiment allows the viewer ample room to identify with the pictures and have the images speak to their own circumstances. The artist has also extended the series by making negative prints of the same images, which further play up the contrast between the black and white tattoos while also calling into question the positive and negative qualities of the concept of "forever." Is "forever" the romantic utopia we all seek, or is it a life sentence, the notorious ball-and-chain as barrier to freedom?

Other tattoo and photo-works explore a similar nexus of bad-boy bravado and sensitive soul-mate, such as *Tattoo (I)* and *Tattoo (II)* (both 1994). Although they are individual works, these two vertically oriented photographs operate most effectively as a pair. In one a disembodied arm reaches downward, and in the other an arm reaches up from below. In both photos the artist's upper arm is tattooed with the words "Trust Me"; when shown together, they form a potential link between two bodies trying to connect. The simple manipulation of the orientation of the photographs (with a slight adjustment of the hand position) shifts the meaning dramatically: *Tattoo (I)* shows an arm stretching with benevolence

invoking choices of faith in God or the lure of the devil—a favorite, seemingly inexhaustible theme of the artist.

Three Inches (Black) (1997) treads related territory, and is one of the artist's richest and most complex pieces to date. It exemplifies Gordon's engagement with the dialectic of good and evil, thrillingly conflating the desire for emotional contact with the desire to do harm. Comprising eleven color photographs of various sizes, each image in *Three Inches (Black)* shows an index finger covered in black ink. The hands are shown in different positions —clasped together, at rest on a flat surface, in a form of display— but all have the look of medical photographs documenting a grotesque ailment that seems to afflict the left forefinger of its victim. The fact that the "sinister" hand was chosen by Gordon is surely no accident, and the proposal that a tattoo be created to cover three inches of this particular digit with saturated black ink derives from the artist's continued fascination with a story he heard in his youth. According to the tale, a police crackdown on

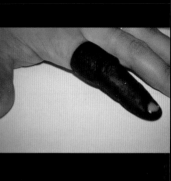

someone's heart," — fatal if carried out literally, but deeply moving as a metaphor.[8] The black residue of the tattoo suggests itself as the index of an action, whether the benign testing of some inky substance or some other more malevolent probing. Regardless of intention, the ominous stain marks any action by the bearer with a nihilistic equality: damned if you do, damned if you don't.

In Gordon's mesmerizing universe of polar opposites, the noble quest for romantic love is often the perfect foil for his explorations into the ignoble aspects of the human condition. The ambiguity of his references to relationships does not discount the importance of longing and desire to his overall project. Rather, the detection of such sentiment, however embedded, becomes the starting point for a fascinating complication of numerous artworks. The examination of such a detail in Gordon's work becomes, to use his words, "the focus on that which should not be seen, should not be examined, [and] can completely undermine the larger system in which the detail has its natural home. I like the idea that a rupture or a perversion of a large system can occur through the focus on ambiguous detail, and that this can alter the whole fabric of society."[9] Thus it is the lurking subtexts, such as the ones discussed here, as much as the big issues he takes on, that have the power to dramatically transform meaning, keeping viewers constantly on guard for shifting vectors of interpretation. No matter how settled one gets in any particular reading of a work by Gordon, there is always a nagging ambivalence. As the artist himself has deviously said of the events brought on by such a "discovery of detail": "Sometimes this can be positive, and sometimes this can be negative."[10]

NOTES

1. Douglas Gordon, "... in conversation: jan debbaut and douglas gordon," in *Douglas Gordon: Kidnapping* (Eindhoven, The Netherlands: Stedelijk Van Abbemuseum, 1998), 23.

2. Ibid., 49.

3. Ibid., 20.

4. Ibid., 31.

5. Ibid., 18.

6. Ibid., 17.

7. "... *letter to agnès*" (1997), in Mark Francis, ed., *Douglas Gordon • Black Spot* (Liverpool: Tate Gallery Liverpool, 2000), 321–22.

8. Ibid., 322.

9. Gordon, in *Kidnapping*, 28–29.

10. Ibid., 29.

WHITE LIES
FRANCIS MCKEE

On Peckham Rye (by Dulwich Hill) it is, as he will in after years relate, that while quite a child, of eight or ten perhaps, he has his "first vision." Sauntering along, the boy looks up and sees a tree filled with angels, bright angelic wings bespangling every bough like stars. Returned home he relates the incident, and only through his mother's intercession escapes a thrashing from his honest father, for telling a lie. Another time, one summer morn, he sees the haymakers at work, and amid them angelic figures walking.[1]

If he be Mr. Hyde ... I shall be Mr. Seek.[2]

You know, dear, the first time you saw God was when You were four years old And he put his head to the window and set you ascreaming.[3]

[He] could throw a veil over his eyes and find himself in a *camera obscura*, where all the features of a scene were reproduced in a form more pure and perfect than they had been originally presented to his external senses.[4]

I can but give an instance or so of what part is done sleeping and what part awake, and leave the reader to share what laurels there are, at his own nod, between myself and my collaborators; and to do this I will first take a book that a number of persons have been polite enough to read, the *Strange Case of Dr. Jekyll and Mr. Hyde*. I had long been trying to write a story on this subject, to find a body, a vehicle, for that strong sense of man's double being which must at times come in upon and overwhelm the mind of every thinking creature. I had even written one, *The Travelling Companion*, which was returned by an editor on the plea that it was a work of genius and indecent, and which I burned the other day on the ground that it was not a work of genius, and that *Jekyll* had supplanted it. Then came one of those financial fluctuations

pages 87–111
Hand with Spot, 2001
Thirteen digital C-prints
57¼ x 48 inches

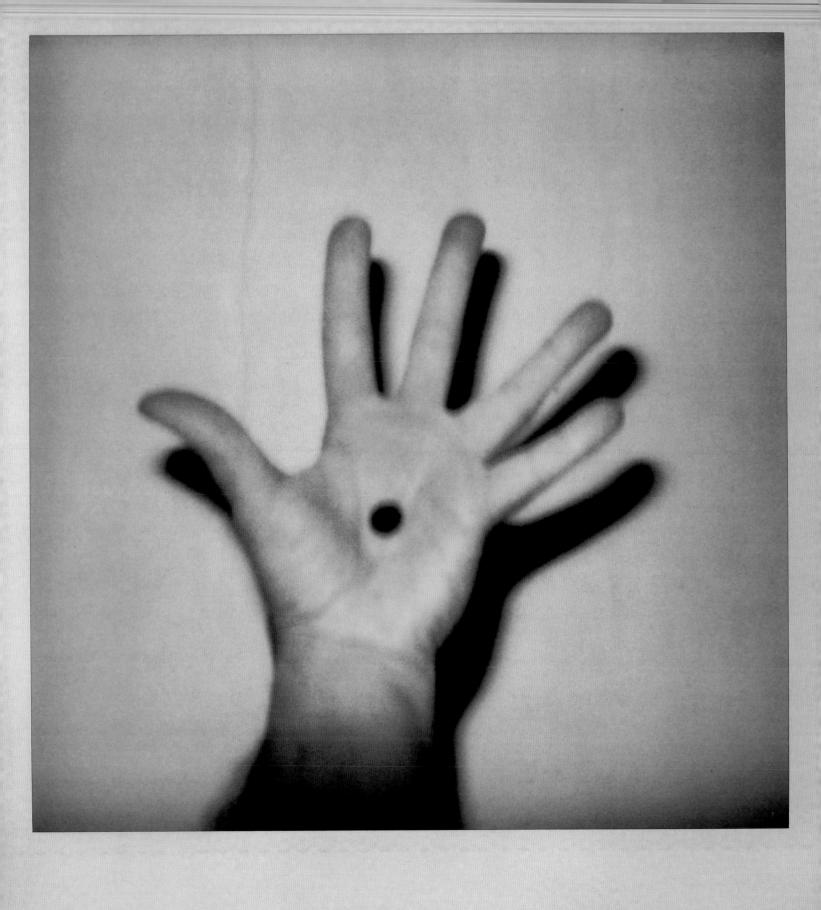

to which (with an elegant modesty) I have hitherto referred in the third person. For two days I went about racking my brains for a plot of any sort; and on the second night I dreamed the scene at the window, and a scene afterwards split in two, in which Hyde, pursued for some crime, took the powder and underwent the change in the presence of his pursuers. All the rest was made awake, and consciously, although I think I can trace in much of it the manner of my Brownies. The meaning of the tale is therefore mine, and had long pre-existed in my garden of Adonis, and tried one body after another in vain; indeed, I do most of the morality, worse luck! and my Brownies have not a rudiment of what we call a conscience. Mine, too, is the setting, mine the characters. All that was given me was the matter of three scenes, and the central idea of a voluntary change becoming involuntary.[5]

And then, while he was yet a student, there came to him a dream-adventure which he has no anxiety to repeat; he began, that is to say, to dream in sequence and thus to lead a double life—one of the day, one of the night—one that he had every reason to believe was the true one, another that he had no means of proving to be false. I should have said he studied, or was by way of studying, at Edinburgh College, which (it may be supposed) was how I came to know him. Well, in his dream life, he passed a long day in the surgical theatre, his heart in his mouth, his teeth on edge, seeing monstrous malformations and the abhorred dexterity of surgeons. In a heavy, rainy, foggy evening he came forth into the South Bridge, turned up the High Street, and entered the door of a tall *land*, at the top of which he supposed himself to lodge. All night long, in his wet clothes, he climbed the stairs, stair after stair in endless series, and at every second flight a flaring lamp with a reflector. All night long, he brushed by single persons passing downward—beggarly women of the street, great, weary, muddy labourers, poor scarecrows of men, pale parodies of women—but all drowsy and weary like himself, and all single, and all brushing against him as they passed. In the end, out of a northern window, he would see

day beginning to whiten over the Firth, give up the ascent, turn to descend, and in a breath be back again upon the streets, in his wet clothes, in the wet, haggard dawn, trudging to another day of monstrosities and operations. Time went quicker in the life of dreams, some seven hours (as near as he can guess) to one; and it went, besides, more intensely, so that the gloom of these fancied experiences clouded the day, and he had not shaken off their shadow ere it was time to lie down and to renew them. I cannot tell how long it was that he endured this discipline; but it was long enough to leave a great black blot upon his memory, long enough to send him, trembling for his reason, to the doors of a certain doctor; whereupon with a simple draught he was restored to the common lot of man.[6]

Opposition is true Friendship.[7]

Mr. Golyadkin caught his breath. The stranger stopped exactly before the house in which Mr. Golyadkin lodged. He heard a ring at the bell and almost at the same time the grating of the iron bolt. The gate opened, the stranger stooped, darted in and disappeared. Almost at the same instant Mr. Golyadkin reached the spot and like an arrow flew in at the gate. Heedless of the grumbling porter, he ran, gasping for breath, into the yard, and immediately saw his interesting companion, whom he had lost sight of for a moment.

The stranger darted towards the staircase which led to Mr. Golyadkin's flat. Mr. Golyadkin rushed after him. The stairs were dark, damp and dirty. At every turning there were heaped-up masses of refuse from the flats, so that any unaccustomed stranger who found himself on the stairs in the dark was forced to travel to and fro for half an hour in danger of breaking his legs, cursing the stairs as well as the friends who lived in such an inconvenient place. But Mr. Golyadkin's companion seemed as though familiar with it, as though at home; he ran up lightly, without difficulty, showing a perfect knowledge of his surroundings. Mr. Golyadkin had almost caught him up; in fact, once or twice the stranger's coat flicked him on the nose. His heart stood still.

The stranger stopped before the door of Mr. Golyadkin's flat, knocked on it, and (which would, however, have surprised Mr. Golyadkin at any other time) Petrushka, as though he had been sitting up in expectation, opened the door at once and, with a candle in his hand, followed the stranger as the latter went in. The hero of our story dashed into his lodging beside himself; without taking off his hat or coat he crossed the little passage and stood still in the doorway of his room, as though thunderstruck. All his presentiments had come true. All that he had dreaded and surmised was coming to pass in reality. His breath failed him, his head was in a whirl. The stranger, also in his coat and hat, was sitting before him on his bed, and with a faint smile, screwing up his eyes, nodded to him in a friendly way. Mr. Golyadkin wanted to scream, but could not—to protest in some way, but his strength failed him. His hair stood on end, and he almost fell down with horror. And, indeed, there was good reason. He recognized his nocturnal visitor. The nocturnal visitor was no other than himself—Mr. Golyadkin himself, another Mr. Golyadkin, but absolutely the same as himself—in fact, what is called a double in every respect....[8]

Please allow me to introduce myself...[9]

I am a man of substance, of flesh and bone, fiber and liquids — and I might even be said to possess a mind. I am invisible, understand, simply because people refuse to see me. Like the bodiless heads you see sometimes in circus sideshows, it is as though I have been surrounded by mirrors of hard, distorting glass. When they approach me they see only my surroundings, themselves, or figments of their imagination—indeed, everything and anything except me.[10]

And before him shall be gathered all nations: and he shall separate them one from another, as a shepherd divideth *his* sheep from the goats:

And he shall set the sheep on his right hand, but the goats on the left.[11]

Since each of us was several, there was already quite a crowd. Here we have made use of everything that came within range, what was closest as well as farthest away. We have assigned clever pseudonyms to prevent recognition. Why have we kept our own names? Out of habit, purely out of habit. To make ourselves unrecognizable in turn. To render imperceptible, not ourselves, but what makes us act, feel, and think. Also because it's nice to talk like everybody else, to say the sun rises, when everybody knows it's only a manner of speaking. To reach, not the point where one no longer says I, but the point where it is no longer of any importance whether one says I. We are no longer ourselves. Each will know his own. We have been aided, inspired, multiplied.[12]

Trust between the two the common denominator and the base upon which all is built.... It takes planning, preparation: spiritually, mentally and physically.... It becomes a form of meditation, when practised, it is second nature. The hands almost separate from the body and you are a spectator watching the rope weaving its way around a body. Becoming one with it. The knots, loops and ties being separate thoughts, the rope a central stream of consciousness from which those thoughts escape.[13]

I've played with dangerous knowledge. I've walked a strange and terrible road.[14]

It had thundered on the Friday night, but the sun rose on Saturday without a cloud. We were at sea — there is no other adequate expression — on the plains of Nebraska. I made my observatory on the top of a fruit-waggon, and sat by the hour upon that perch to spy about me, and to spy in vain for something new. It was a world almost without a feature; an empty sky, an empty earth; front and back, the line of railway stretched from horizon to horizon, like a cue across a billiard-board; on either hand, the green plain ran till it touched the skirts of heaven.... The train toiled over this infinity like a snail; and being the one thing moving, it was wonderful what huge proportions it began to assume in our regard. It seemed miles in length, and either end of it within but a step of

the horizon. Even my own body or my own head seemed a great thing in that emptiness.[15]

I'm entering it, and part of me is trying to surround them as well. I like the metaphor of getting under somebody's skin as I like playing with piercings, whether they're temporary or permanent. I like activities that get into somebody's system. I like the feeling of tapping into someone's body and swimming in their veins.[16]

It is very hard to murder or be murdered by a fat man.[17]

At every turn we could see farther into the land and our own happy futures. At every town the cocks were tossing their clear notes into the golden air, and crowing for the new day and the new country. For this was indeed our destination; this was "the good country" we had been going to so long.

By afternoon we were at Sacramento, the city of gardens in a plain of corn; and the next day before the dawn we were lying to upon the Oakland side of San Francisco Bay. The day was breaking as we crossed the ferry; the fog was rising over the citied hills of San Francisco; the bay was perfect — not a ripple, scarce a stain, upon its blue expanse; everything was waiting, breathless, for the sun.[18]

My interest in food is cannibalistic. I don't mean I wish to practice cannibalism in the literal sense, but I think there is a figurative or symbolic sense of cannibalism in sexual interchange, in consuming somebody or consuming somebody's energy. For example, I hear people describe the simple act of p-v sex, penis-vagina intercourse, as if the penis is the active party entering the passive vagina. I see the act more as the vagina engulfing and consuming the penis. In an SM sense, as a top I want to get under somebody's skin, to get inside his system, to take his being into me, so there's a certain amount of consuming already: a *delightful* consuming. It's not that I'm sucking somebody dry unwillingly, and personally I don't like black hole vampire bottoms who suck the energy right out of me.[19]

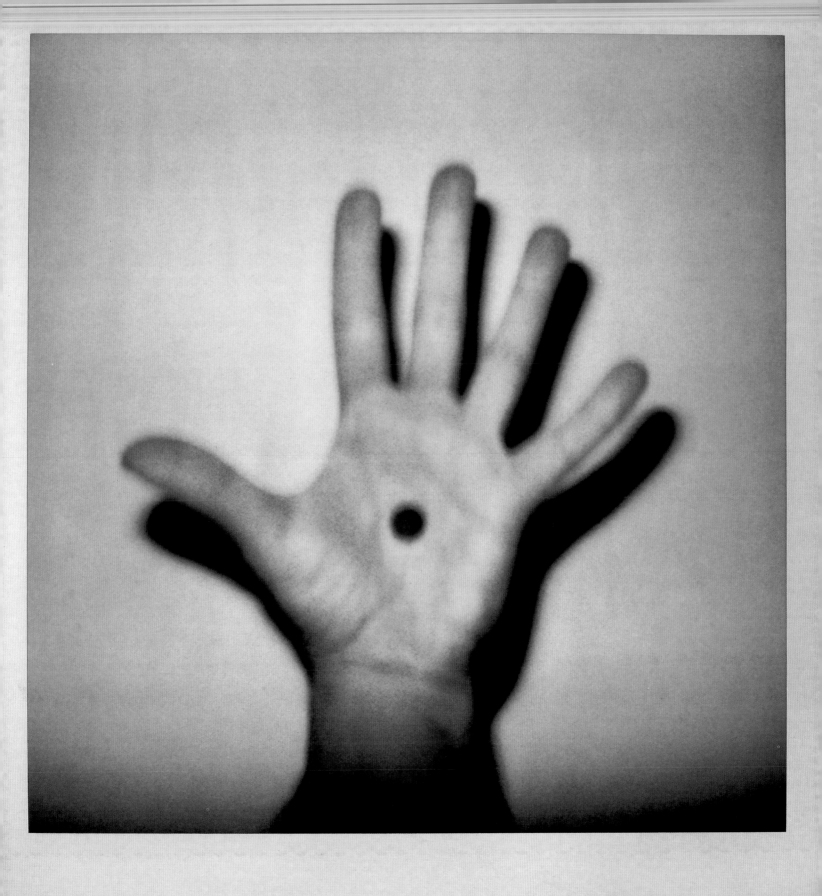

Sometimes Christian charity comes too high. ARBUCKLE was a scapegoat; and the only thing to do with a scapegoat, if you must have one, is to chase him off into the wilderness and never let him come back.[20]

There were also a number of really great, experienced tops, switches, and submissives who visited the house. And after about a year I wanted further training, and I went to Sybil Holiday — Mistress Cybelle. She did a full feminization on me. [laughs] I was the original androgynous boy/girl when Sybil got her hands on me and she taught me a great deal about makeup, as she does with many of her crossdressing clients. She taught me about my femininity.

Did you like that?

I did. I did. I turned into a girl. Then Sybil introduced me to Cléo … who took my bondage training to the next level — a level I almost didn't dare dream of when I first started. I still work with Cléo regularly, as her helper and submissive. We have a very established, trusting relationship.[21]

Do you still feel you're a Catholic?
According to the Church?
In the same way I'm a Protestant.
I'm afraid so. We started talking about fulfilment. There's nothing worth anything else.
What role does it play in your life?
Are you talking about Mass, confession…?
No, I guess I'm talking about private thoughts, imagery. What goes on when the lights go out.
You fight the devil.[22]

And *as for* you, O my flock, thus saith the Lord GOD; Behold, I judge between cattle and cattle, between the rams and the he goats.[23]

I felt God throughout the evening. He loved me. I loved Him. Our marriage was solemnized. In the carriage I told my wife that today was the day of my marriage to God. She felt this in the

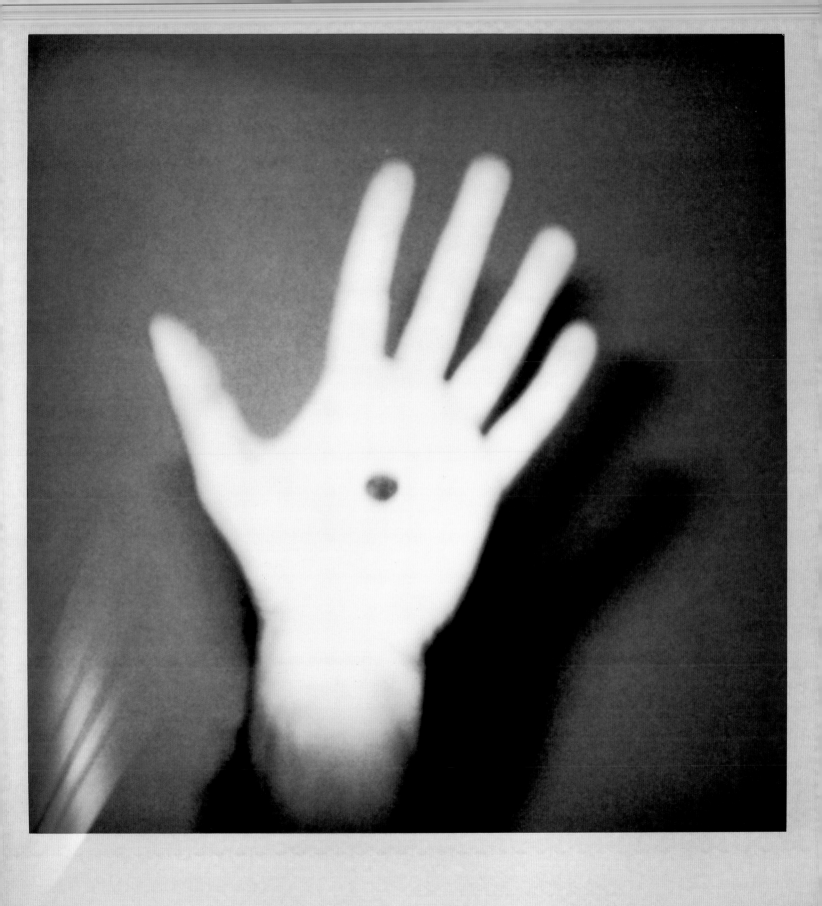

carriage, but lost the feeling in the course of the evening. I loved her and therefore gave her my hand, saying that I felt good. She felt the opposite. She thought I did not love her, because I was nervous. The telephone is ringing, but I will not answer it, because I do not like talking on the telephone. I know my wife wants to answer it. I left the room and saw my wife in her pajamas. She likes sleeping in her pajamas. She loves me and therefore made me feel that I must go up to our bedroom.[24]

My eyes are broken.[25]

Left-handedness versus right-handedness, as for example what is meant by those terms with, say, a mirror image — in which the left hand "becomes" the right hand... How would you define a left-hand glove compared to a right-hand glove so a person who had no knowledge of those terms could tell you which you meant? And not get the other? The mirror opposite?... *It is as if one hemisphere of your brain is perceiving the world as reflected in a mirror*. Through a mirror. See? So left becomes right, and all that that implies. And we don't know yet what that does imply, to see the world reversed like that. Topologically speaking, a left-hand glove is a right-hand glove *pulled through infinity*.[26]

L.A. looked bright and beautiful. I knew I'd pursue some kind of swinging fucking destiny right here...[27]

It was a hot afternoon, and I can still remember the smell of honeysuckle all along that street. How could I have known murder can sometimes smell like honeysuckle?[28]

I went upstairs and went to my bed, but I took a notebook in order to write down everything I had experienced today. I have experienced a lot and therefore want to write it all down. I have experienced nothing but horrible things. I am afraid of people because they do not feel me, but understand me. I am afraid of people because they want me to lead the same kind of life as they do. They want me to dance jolly and cheerful things. I do not like jollity. I love life. My wife sleeps

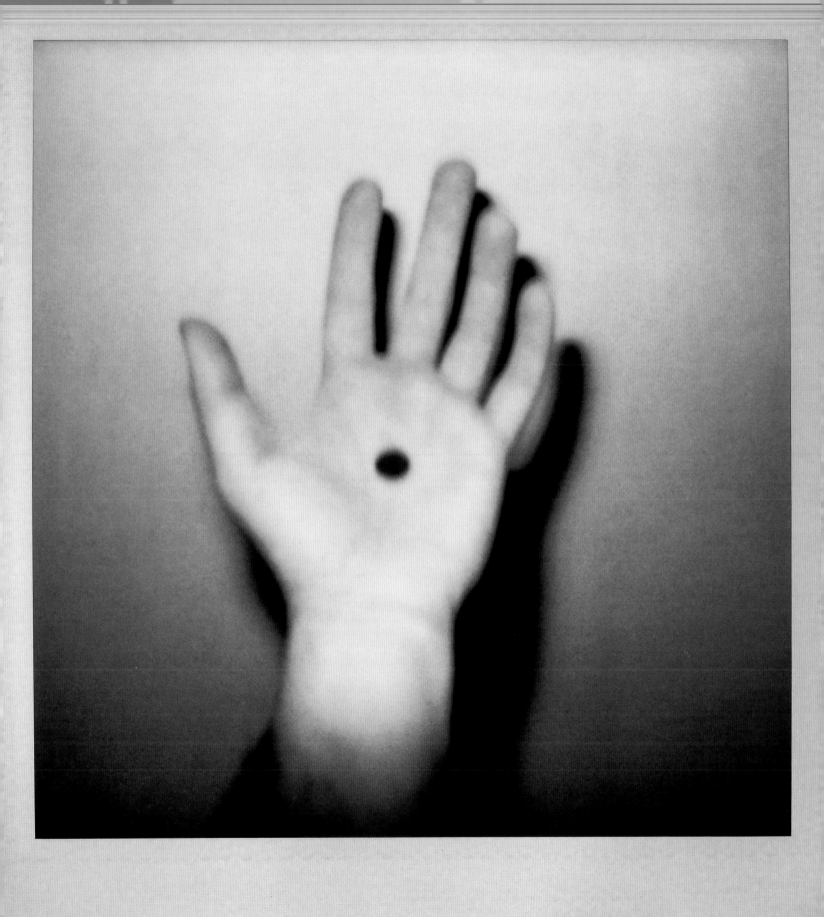

next to me, and I am writing. My wife is not asleep, because her eyes are open. I stroked her. She feels things well. I am writing badly because I find it difficult. My wife is sighing because she feels me. I feel her and therefore do not respond to her sighs. She loves me with feeling today. Someday I will tell her that we must marry in feeling, because I do not want to love without feeling. For now, I will leave it alone, because she is afraid of me.[29]

The kid turned around and started going into something insane right away, "Aw I'm sorry, shit I'm sorry, oh no man I'm *sorry*." Some hot stinking metal had been put into my mouth, I thought I tasted brains there sizzling on the end of my tongue…and somewhere in there I got the feeling that it was him, somehow he'd just killed me. I don't think I said anything, but I made a sound that I can remember now, a shrill blubbering pitched to carry more terror than I'd even known existed, like the sounds they've recorded off of plants being burned, like an old woman going under for the last time. My hands went flying everywhere all over my head, I had to find it and touch it. There seemed to be no blood coming from the top, none from the forehead, none running out of my eyes, my *eyes!*[30]

Ecstasy slips so quickly from the loins to the praying hands … the whole Christian ethic is woven thusly — the gold thread of the spirit and the scarlet thread of the flesh…[31]

Please make it quick, fast and furious. Please. Fast and furious. Please help me get out; I am getting my wind back, thank God. Please, please, oh, please.[32]

[S]ince it has been said that you are my twin and true companion, examine yourself that you may understand who you are … I am the knowledge of the truth.[33]

I got a list of people as long as my leg I wouldn't want cloned.[34]

You want to be scathed? Yeah, so it looks like I didn't give up without a struggle. Whoa! Okay, that's cool, thank you. That's enough. No, wait. Ahh! Scathed? Scathed.[35]

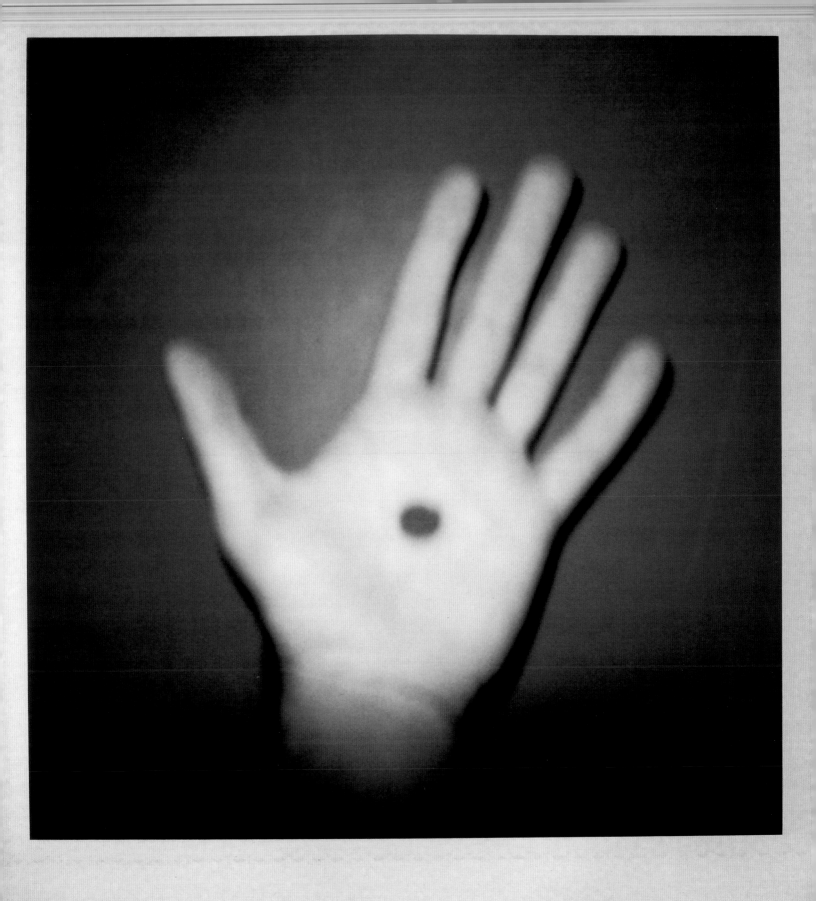

I am afraid to sleep for fear of what I might learn when I wake up. There is no human being within 500 miles to whom I can communicate anything—much less the fear and loathing that is on me after today's murder. God knows I might go mad for lack of talk. I have become like a psychotic sphinx—I want to kill because I can't talk.[36]

Please get me up, my friends. Please, look out, the shooting is a bit wild, and that kind of shooting saved a man's life....

I am sore and I am going up and I am going to give you honey if I can. Mother is the best bet and don't let Satan draw you too fast....

Control yourself....

But I am dying.[37]

This is the end of reason, the dirtiest hour in our time.[38]

Then pull me out. I am half crazy. They won't let me get up. They dyed my shoes. Open those shoes. Give me something. I am so sick. Give me some water, the only thing that I want. Open this up and break it so I can touch you. Dannie, please get me in the car.[39]

[I am] control and the uncontrollable.
I am the union and the dissolution.
I am the abiding and I am the dissolving.
I am the one below,
 and they come up to me.
I am the judgment and the acquittal.[40]

Come on, open the soap duckets. The chimney sweeps.
Talk to the sword. Shut up, you got a big mouth! Please help me up, Henny. Max, come over here. French-Canadian bean soup. I want to pay. Let them leave me alone....

Ok, ok, I am all through. Can't do another thing.[41]

NOTES

1. Alexander Gilchrist, *Life of William Blake; with Selections from his Poems and Other Writings*, vol. 1 (1880; reprint, New York: Phaeton Press, 1969), 7.

2. Robert Louis Stevenson, *Dr. Jekyll and Mr. Hyde* (1886; reprint, New York: Signet, 1987), 49.

3. William Blake's wife to Blake, quoted in Henry Crabb Robinson, *Diary, Reminiscences, and Correspondences of Henry Crabb Robinson* (1869). Reprinted in G. E. Bentley, Jr., *Blake Records* (Oxford: Oxford University Press, 1969), 542–43.

4. A comment on Percy Bysshe Shelley, quoted in Herbert Read, *Education Through Art* (London: Faber and Faber, 1958), 42.

5. Robert Louis Stevenson, *Across the Plains; with Other Memories and Essays* (1892; reprint, New York: Scribner's, 1937), 227–28.

6. Ibid., 211–13.

7. William Blake, plate 20, *The Marriage of Heaven and Hell* (c. 1790; reprint, Oxford: Oxford University Press and The Trianon Press, 1990), xxv.

8. Fyodor Dostoevsky, *The Double* (1846), in *The Short Novels of Dostoevsky*, trans. Constance Garnett (New York: Dial Press, 1945), 514–15.

9. The Rolling Stones (Jagger/Richards), "Sympathy for the Devil," *Beggars Banquet* (ABKCO Records, 1968).

10. Ralph Ellison, *Invisible Man* (1952; reprint, New York: Vintage, 1989), 3.

11. Matthew 25:32–33.

12. Gilles Deleuze and Félix Guattari, *A Thousand Plateaus: Capitalism and Schizophrenia*, trans. Brian Massumi (Minneapolis: University of Minnesota Press, 1987), 3.

13. "Bondage & Restraint: Loss of Motion=Loss of Control=Freedom of the Mind," http://www.bdsm-online.com/play/bondage.htm.

14. Richard J. Anobile, ed., *Rouben Mamoulian's Dr. Jekyll & Mr. Hyde, Starring Fredric March* (New York: Darien House and Universe, 1975), 127.

15. Stevenson, *Across the Plains*, 42–43.

16. William A. Henkin, "Interview with Mistress Midori," http://www.sexuality. org/l/wh/midori.html. Originally published in *Spectator* (1997).

17. Fatty Arbuckle, quoted in Paul H. Henry, "Roscoe 'Fatty' Arbuckle: Profile of an American Scandal," 4 April 1995, http://www.phenry.org/text/arbuckle.txt.

18. Stevenson, *Across the Plains*, 76–77.

19. Henkin, "Interview with Mistress Midori."

20. "Hays and Arbuckle," *The New York Times*, 22 December 1922, 14.

21. William A. Henkin, "Kira: Interview with a Domme," http://www.spectatormag. com/NEW_ARCHIVES/kira2.html. Originally published in *Spectator* (19 February 1999).

22. Paul Schrader, "Interview with Martin Scorsese by Paul Schrader" (1982), in *Taxi Driver* (London: Faber and Faber, 1990), xxi.

23. Ezekiel 34:17.

24. Vaslav Nijinsky, *The Diary of Vaslav Nijinsky*, trans. Kyril Fitzlyon, ed. Joan Acocella (New York: Farrar, Straus and Giroux, 1999), 7–8.

25. Michael Peppiatt, *Francis Bacon: Anatomy of an Enigma* (New York: Farrar, Straus and Giroux, 1997), 255.

26. Philip K. Dick, *A Scanner Darkly* (1977; reprint, New York: Vintage, 1991), 212.

27. James Ellroy, *My Dark Places: An L.A. Crime Memoir* (New York: Knopf, 1996), 125.

28. Richard Schickel, *Double Indemnity* (London: British Film Institute, 1992), 44.

29. Nijinsky, *The Diary of Vaslav Nijinsky*, 8.

30. Michael Herr, *Dispatches* (1968; reprint, New York: Vinatge, 1991), 31–32.

31. Simon Callow, *The Night of the Hunter* (London: British Film Institute, 2000).

32. "Transcript of Death Bed Statements Made by Schultz," *The New York Times*, 26 October 1935, 6.

33. *The Book of Thomas the Contender*, trans. John D. Turner, in *The Nag Hammadi Library: In English* (New York: Harper & Row, 1977), 189.

34. "46 Long," episode two of *The Sopranos*, Home Box Office © 1999. Transcript found at http://www.sopranoland.com/episodes/ep02/transcript/index.html.

35. Ibid.

36. Hunter S. Thompson, *The Proud Highway: Saga of a Desperate Southern Gentleman, 1955–1967*, vol. 1 of *The Fear and Loathing Letters*, ed. Douglas Brinkley (New York: Villard, 1997), 420.

37. "Transcript of Death Bed Statements Made by Schultz," 6.

38. Thompson, *The Proud Highway*, 420.

39. "Transcript of Death Bed Statements Made by Schultz," 6.

40. *The Thunder, Perfect Mind*, trans. George W. MacRae, ed. Douglas M. Parrott, in *The Nag Hammadi Library: In English*, 276.

41. "Transcript of Death Bed Statements Made by Schultz," 6.

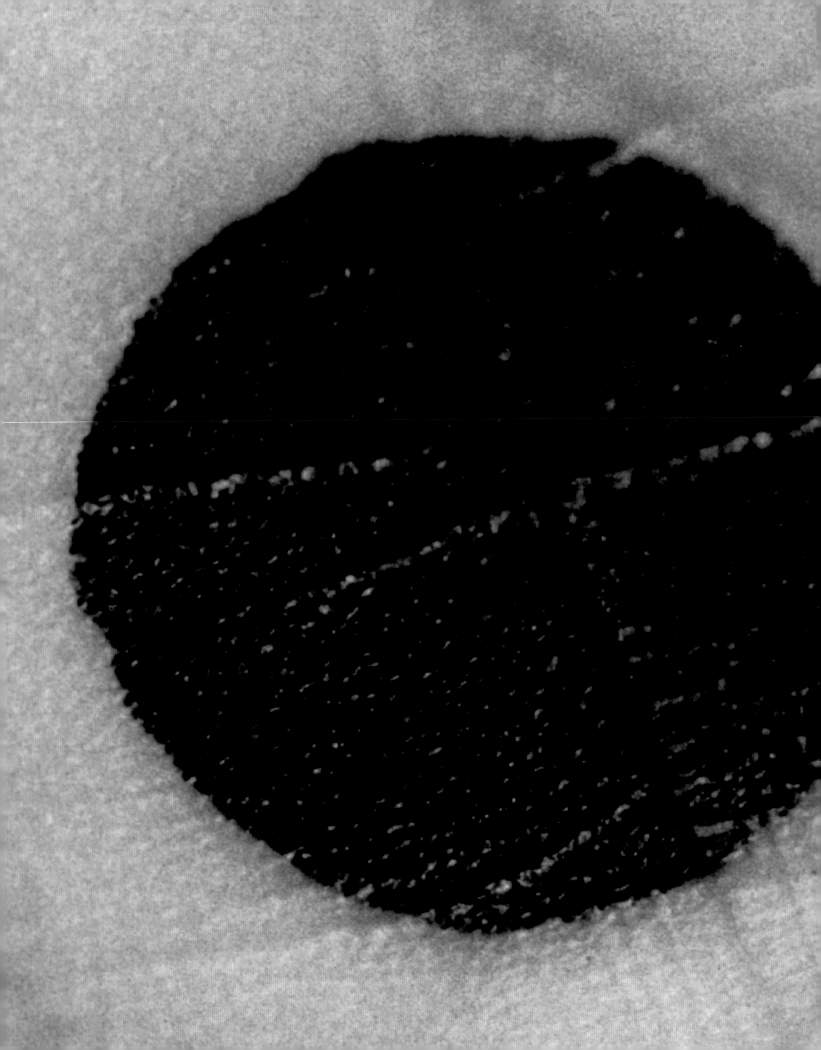

NANCY SPECTOR

In Douglas Gordon's work one is never quite sure where the art begins or ends. It is not that real life and the artistic gesture commingle in some kind of Warholian embrace of the low. It's just that fantasy and reality refuse to part company. Gordon perpetuates this confusion between fact and fiction by turning the most mundane forms of communication — letters, billboards, telephone calls — into works of art. Such is the case with the catalogue accompanying his solo exhibition at the Tate Liverpool, "Douglas Gordon • Black Spot." Its cover and page trim are the color of night, punctuated only by a large white "g" on the front cover and "d" on the back — for "Gordon, Douglas," one assumes. Because the book occupies the space between these two letters, the initials can also appear to spell out "g—d," in the manner that the name is transcribed in orthodox religious doctrines. However, in Gordon's dialectical universe, where polar opposites such as the sacred and the profane collapse into one another, this monogram could also imply its antithesis, i.e., Satan himself.

References to the battle between salvation and damnation pervade the book, which, as an anthology of the artist's text-based works, begins with 112 pages of source material drawn from the worlds of film, literature, medical science, theology, and popular music. This elaborate prologue is composed of radically cropped pages from evangelical pamphlets published by the Jehovah's Witnesses; excerpts from books on medieval medicine and nineteenth-century psychopathology; souvenir posters from Hollywood cinema; stills from John Ford's *The Searchers* (1956), Alfred Hitchcock's *The Birds* (1963) and *Vertigo* (1958), Martin Scorsese's *Taxi Driver* (1976), and Andy Warhol's *Empire* (1964);

Black Spot, 2000
Digital C-print
40 x 30 inches

consciousness; he commits them with a lucid satisfaction. He is not mad; but he is possessed; we see him little by little yielding to the persuasion of a powerful friend whom he recognizes, only when it is too late, as the very devil himself — though the devil is never actually named. One of the major interests of the book is the figurative portrayal of states of subjective consciousness and the slow exposition of the something possibly flattering in this progressive acquaintanceship with the Prince of Darkness. When the sinner, at last undeceived, tries to disengage himself from this frightful hold, it is too late. The Other possesses him and will never let go his prey.

No doubt it was necessary that this book should try or feign to be edifying. . . . Otherwise it would not have been tolerated. But I doubt whether Hogg's personal point of view is that of true religion or whether it is not rather that of reason, common sense and a natural Tom Jones-like [openness], which is that of the 'justified sinner's' bro[ther when] the 'justified' murders out of a jealous and [brotherly] hatred and, moreover, with the desire of getting [his] elder brother's share of their father's inheri[tance this he does with the ingenious] claim of commit[ting] such a murder as a pious deed.

[Hogg]'s sympathy evidently goes to this charming [young man] of normal humanity, spontaneous, gay, rich [in possib]ilities and in no wise encumbered with religious preoccupations, so that our 'antinomian' quite naturally [considers] him as one of the accursed, of whom it is important to purge the world. His demon-friend fools him into believing that God has created him in order to effect this purgation. All fanaticism is capable of bringing forth similar dispensers of Justice. This one had been accustomed from youth upwards, 'to pray twice every day and seven times on Sabbath days,' says Hogg, 'but he was only to pray for the elect, and, like David of old, doom all that were aliens from God to destruction' (p. 18). Mr. Wringhim, his adoptive father, inculcates these 'antinomian' principles into the mind and heart of young Robert and piously cultivates his native inclination to hatred, thinking to sanctify it by placing it at the service of the Lord. Wringhim is a member of this redoubtable sect. He admits Robert, a[s]

10

pin-up pictures of bikini-clad starlets from the 1950s; polaroids of Edie Sedgwick; snippets from Hieronymous Bosch's views of hell; and the occasional reference to John Lennon, Sonic Youth, the Beastie Boys, and Kenneth Anger, among others. Interspersed with these montaged images are a series of postcards that Gordon received from Graham Gussin during an eighteen-month correspondence (1993–94) in which the artists exchanged their opinions on the best songs ever recorded: "Jumpin' Jack Flash," "Children of the Revolution," "Love Will Tear Us Apart," and so on.

One critical source — perhaps the elemental source for Gordon's work — is not to be found in this introductory compendium. Rather, it is embedded in the body of the book, in the main section devoted to the artist's linguistic pieces. Amidst reproductions of his letters, short stories, tattoos, and installations, Gordon illustrated a double-page spread from James Hogg's gothic novel *The Private Memoirs and Confessions of a Justified Sinner* (1824), on which he circled the name of the main character, the doomed Robert Wringhim. He then added to this enigmatic layout by superimposing the oddly anachronistic email address robertwringhim@ compuserve.com.[1]

It is no secret that Gordon has been inspired by Hogg's classic tale of demonic possession and double identity. He appropriated its title for his split-screen video installation *Confessions of a Justified Sinner* (1995/96), which conflates two exemplary narratives of schizophrenia and the occult with its footage from Rouben Mamoulian's 1931 film *Dr. Jekyll and Mr. Hyde*. But the attention given to Hogg's novel in the "Black Spot" catalogue — its facsimile reproduction is located in the very center of the section chronicling Gordon's text pieces — proves its significance to the artist's work as a whole. It also helps to know, of course, that the email address is Gordon's own. The fictional Robert Wringhim is thus

Page from **Douglas Gordon•Black Spot**
Published by Tate Liverpool, 2000

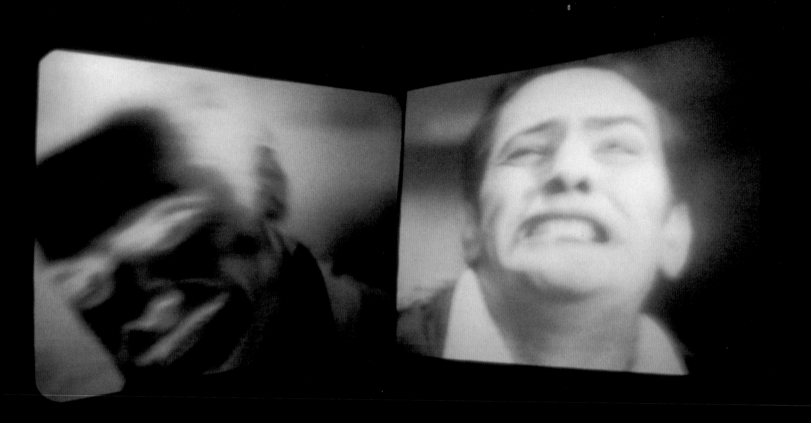

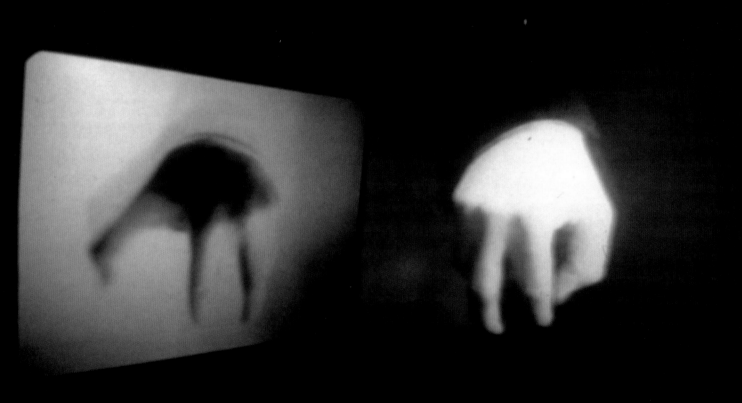

Gordon's *nom de plume*, his literary other, his electronic identity. This revealing but no doubt highly studied inclusion in the catalogue offers a tantalizing clue into the artist's conceptual strategies. Like Hogg's two-part novel about self-division and supernatural dualism, Gordon's multivalent work circulates around conditions of doubling as both structure and metaphor. Throughout his entire project, he equates content with form, playing one off the other in a provocative game of innuendo and aesthetic affect. The veiled confession about his alter ego — a positively criminal one at that — reveals two other essential facets of the work: Gordon is often present in it, albeit in disguise, and nothing about it should be taken at face value.

Gordon's adoption of "Robert Wringhim" as a pseudonym indicates less an identification with the character's moral plight — which led from spirituality to criminality — than a fascination with the structure of Hogg's divided narrative. Two entirely separate points of view, which the reader encounters sequentially, relay the plot. Thus the story is told twice. It is premised on the discovery of Wringhim's tormented confessions, which recount his fall from grace.

The bastard son of a fire-and-brimstone Calvinist minister and an extravagantly pious mother, Wringhim had been brought up to believe he was a member of the church's elect and thus predestined for salvation no matter how grievous his sins. His self-righteousness in the face of all he perceived to be less than devout validated his most heinous of acts against friends and family. He was aided and abetted in his crimes by a mysterious friend named Gil-Martin, who resembled him utterly, read his thoughts, and fueled his most destructive tendencies. The question of whether Wringhim's elusive companion was the devil incarnate or the product of a diseased mind is never answered in the book. On the

Stills from **Confessions of a Justified Sinner**, 1995/96
Video installation
Dimensions variable

...hot is cold, day is night, lost is found, everywhere is nowhere, something is nothing, pain is pleasure, blindness is sight, hell is heaven, confinement is freedom, black is white, inside is outside, famine is surplus, bad is good, nature is synthetic, life is death, fiction is reality, equilibrium is crisis, doubt is faith, hypocrisy is honesty, feminine is masculine, open is closed, neglect is cultivation, laughing is crying, contaminated is pure, blessing is damnation, construction is demolition, blunt is sharp, sweet is bitter, satisfaction is frustration, depression is elation, nightmares are dreams, flying is falling, water is blood, truth is a lie, hate is love, trust is suspicion, shame is pride, sanity is lunacy, outside is inside, forward is backward, shit is food, dark is light, right is wrong, left is right, future is past, old is new, losing is winning, work is play, attraction is repulsion, screaming is silence, desire is fulfilment, I am you, you are me, fulfilment is desire, silence is screaming, repulsion is attraction, play is work, winning is losing, new is old, past is future, right is left, wrong is right, light is dark, food is shit, backward is forward, inside is outside, lunacy is sanity, pride is shame, suspicion is trust, love is hate, lies are truth, blood is water, falling is flying, dreams are nightmares, elation is depression, frustration is satisfaction, bitter is sweet, sharp is blunt, demolition is construction, damnation is blessing, pure is contaminated, crying is laughing, cultivation is neglect, closed is open, masculine is feminine, honesty is hypocrisy, faith is doubt, crisis is equilibrium, reality is fiction, death is life, synthetic is natural, good is bad, surplus is famine, outside is inside, white is black, freedom is confinement, heaven is hell, sight is blindness, pleasure is pain, nothing is something, nowhere is everywhere, found is lost, night is day, cold is hot...

contrary, Hogg's two-part structure intentionally defers such a narrative resolution. The first section is written by the Editor, who provides a rational, legalistic account of the events surrounding Wringhim's wretched life and suicide. The second is constituted by the confessions themselves, which are wholly subjective, impassioned, and ambiguous. The structure of the book embodies the doppelgänger theme at its core: religious justification is compared to its heretical double, antinomianism; the by-products of psychopathology are compared to events explained only by supernatural intervention; and scientific reasoning is compared to the wiles of folklore.[2]

The coexistence and interpenetrability of good and evil resonate in Gordon's art, which, as in Hogg's tale, is explicated through a kind of structural doubling or formal repetition that suspends any conclusive reading of its ultimate meaning. In this way, Gordon foregrounds his abiding interest in the fact that "what seems to be, is probably not."[3] He demonstrates this paradox in the text piece *Untitled Text (for someplace other than this)* (1996), which inventories sets of divergent concepts — "hot is cold, attraction is repulsion, blessing is damnation" — by presenting them as equations and then inverting their order in a Möbius strip of an installation, which centers around the doppelgänger-like phrase: "I am you, you are me."

It is from such slippages between perceived opposites, especially self and other, present and past, the dead and the undead, that the "Uncanny" emerges. Sigmund Freud experienced the Uncanny — that pervasive sense of dread intrinsic to the Gothic novel — when he encountered his own reflection in a mirror while traveling on an overnight train. Not recognizing his double, he wondered who the old gentleman might be. He described the phenomenon as belonging to the "class of the terrifying which leads to something

Untitled Text (for someplace other than this), 1996
Lettering on wall
Dimensions variable

long known to us, once very familiar."[4] In his view, the double is a figment of the subconscious that guards against primordial fears of estrangement. Repressed, it eventually returns as a portent, a chilling or uncanny sign that death is lurking. Freud arrived at his explanation of the Uncanny through an analysis of the German word *"heimlich,"* the twofold definition of which — something homelike, commonplace, and intimate, but also secret, concealed from view, and furtive — coincides with its opposite, *"unheimlich"* — that which is sinister, eerie, uneasy. For Gordon, who mines the territory of the Uncanny, "the Unheimliche is where it is interesting to be."[5] Schooled in the Gothic literature of his native Scotland, the artist frequently uses his own image (or double) to make the familiar strange or, in a typical Gordonian gesture, to make the strange familiar.

Gordon is an inveterate storyteller. The fictions he weaves extend outward from the actual objects of his art — film, video, and sound installations; photographs; and text works — to encompass his own artistic persona. Self-portraiture or, more accurately, Gordon's presentation of a mutable and enigmatic self constitutes a significant component of his practice, a component that is largely performative and indirect. For instance, the biographical essays in a number of his exhibition catalogues are allegedly authored by an unidentified friend or one of the artist's brothers. They offer glimpses into Gordon's private life through highly controlled (or contrived) accounts of his childhood in Glasgow and recent escapades in the world at large.[6] We learn, for instance, that his mother nearly died during childbirth and for this he has experienced lifelong guilt. We also learn that she left Scotland's Calvinist Church to join the evangelical cult of Jehovah's Witnesses when the artist was six years old and that subsequently he did his share of door-to-door proselytizing. According to his brother David, Gordon was

always "overly concerned by psychological details," a trait he transposed to his art by manipulating the responses of his audience through a certain amount of game playing. And, as one anonymous friend recounts, Gordon lived a "vampire" existence during a residency in Berlin, and claimed to have seen the devil dining at a late-night café.

The artist has adopted a multiplicity of voices to create an image of the real "Douglas Gordon" that is — as in all good art — part truth and part illusion. In doing so, he has deliberately blurred the boundaries between himself and the representation of himself. Even his personal email address is a work of art. Gordon's literary conceits emerged in early, site-specific wall texts with moralistic undertones, such as *Above all else* ... (1991) [We Are Evil]. His texts then migrated out into the world through the (still ongoing) series of letters addressed to unsuspecting members of the art-world that range from the ominously accusing — "I am aware of who you are & what you do" (1991) — to the vaguely romantic — "From the moment you read these words, until you meet someone with brown eyes" (1993).[7] These missives are signed by the artist, whose voice takes on the authoritative tone of an omnipotent observer.

On a more intimate level, Gordon has also inscribed words directly onto his body in the form of tattoos. Though documented in editioned photographs, the tattoos are themselves aesthetic objects and, by extension, they transform the artist's own corporeal presence into a performative work of art. The first tattoo consists of the simple but charged phrase "Trust Me," which Gordon has worn across his upper left arm since 1993.[8] As an expression of reassurance premised on the artist's own moral integrity, the term is also one of seduction. The quintessential come-on line, "trust me" generally indicates there is good reason for suspicion. Gordon

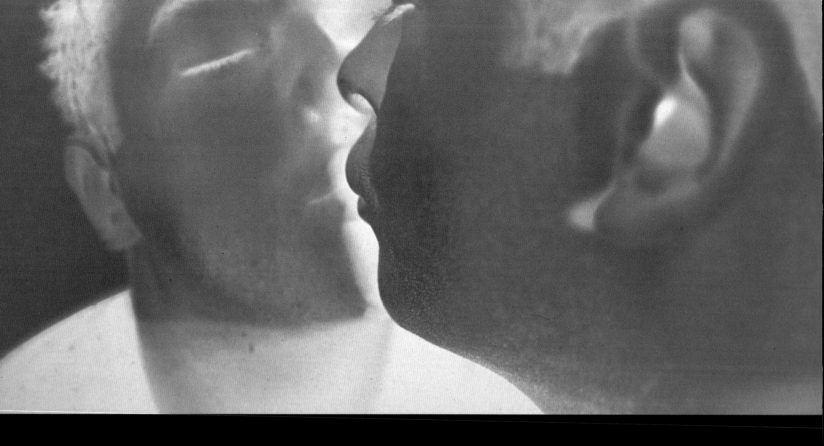

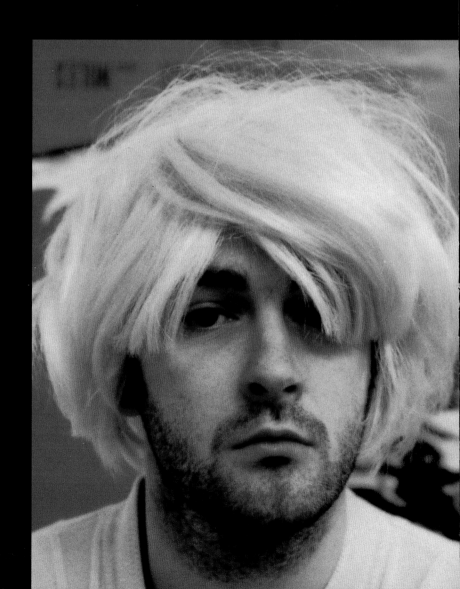

of course, plays it both ways, given his devilish sense of humor and propensity for dualistic thinking. Even his use of the tattoo format — which evolved in Western culture as both a marker for religious servitude and an index for penal punishment — suggests a delight in the mixed message.[9]

When Gordon includes his own image in the work, his features are either obscured or he is depicted undergoing some form of transformation. The slide installations *Kissing with Sodium Pentothal* (1994) and *Kissing with Amobarbital* (1995) document performances in which Gordon purportedly wore truth serum on his lips at gallery openings and greeted each acquaintance with a friendly peck on the mouth. A related work, *Self-portrait (Kissing with Scopolamine)* (1994) shows the artist with eyes closed, lips covered with truth serum, kissing his own reflection in the mirror. Whether he actually wore the drugs — which, in actuality, do not elicit honesty, but rather loosen inhibitions — is impossible to prove. The elusiveness of this and any truth is underscored by the presentation format of the works: all three of the installations use negative slides — photographic inversions in which (in typical Gordon fashion) black is white and white is black. About the *Self-portrait (Kissing with Scopolamine)*, Gordon has stated: "It seemed an exciting thing to me to sum up all these ideas about reflection and mirroring in a single work. Then it would be almost impossible to still find a logic in the picture. The viewer sees a negative of the truth, and a negative of the self, and a negative of the reflection of the self ... I love that kind of endlessness."[10]

This perpetual deferral of resolution informs another photographic piece in which Gordon depicts himself wearing an ill-fitting, unkempt blonde wig. Titled *Selfportrait as Kurt Cobain, as Andy Warhol, as Myra Hindley, as Marilyn Monroe* (1996), the picture shows the artist in masquerade, performing an identity that refuses

Self-portrait (Kissing with Scopolamine) (detail), 1994
35-mm slide projection
Dimensions variable

Selfportrait as Kurt Cobain, as Andy Warhol,

to cohere around references to tabloid personalities that range from pop-cultural icons to a serial killer.[11] Linked by more than their blonde hair, these figures share a certain pathos that has played itself out under the scrutiny of public attention. Theirs were lives in which any boundary between the private and public had been obliterated by the glare of the camera. Granted, Warhol made this the subject of his art with his own portraits of celebrities and criminals, but in doing so, he both captured and embodied the emptiness inherent to the cult of the personality. Cobain and Monroe, though beloved by their fans, ended their own lives. And Hindley, who committed a sequence of grisly murders that shocked Great Britain during the 1960s, has spent the last thirty-five years petitioning the press for early release from her life sentence. When Gordon was awarded the prestigious and highly publicized Turner Prize in 1996, this was the photograph of himself he provided to the media. Whether this gesture was intended as an underhanded critique of the attention usually garnered by this British award, an outright provocation, or a joke at his own expense, is difficult to say. Regardless of intent, *Selfportrait* is yet another instance of the artist distancing himself from his own representation in order to represent himself.

Gordon restaged the multiple-personality disorder invoked in *Selfportrait* for the photographic piece *Monster* (1996–97), which shows him in two conflicting but coexistent states: as a normal young man and as a hideous, disfigured creature. He created this grotesque image of himself with the simplest of means: scotch tape pulled every which way on his face so that the wrong features became taut while others, equally disturbingly, became lax. Such is the revulsion of the familiar made strange, of the idea that something so other, so monstrous could lie as close to the surface. This was the case for Dr. Henry Jekyll, for whom it was "shocking....

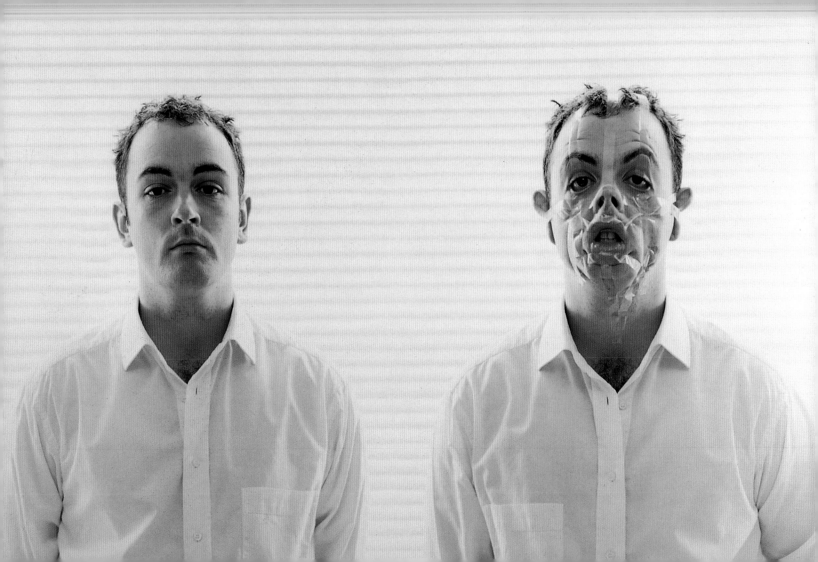

that that insurgent horror was knit to him closer than a wife, closer than an eye; lay caged in his flesh, where he heard it mutter and felt it struggle to be born."[12] In Gordon's picture, there is no sense of before or after; both beings exist simultaneously, like fraternal twins. The lack of struggle between them, the seeming absence of trauma, is perhaps the most uncanny aspect of the work and functions as the *punctum* of the picture.

Gordon cultivates and embraces the sense of unease associated with the double. For a recently initiated, ongoing project, he has actually commissioned his own doppelgänger, a wax effigy of himself from the famed Musée Grévin in Paris. Established in 1882, this museum of waxworks makes the uncanny palpable with its array of historical personages in embalmed states of verisimilitude: Napoleon pauses in his tent during the withdrawal from Moscow; Marie Antoinette beholds a crucifix while awaiting the guillotine; Marat succumbs to death in his bathtub. One can imagine that more recent additions would include John F. Kennedy in his Dallas motorcade or Princess Diana departing from her Paris hotel. The museum's mortuary chill is further intensified in the special underground section devoted exclusively to executions, displaying in detail by gory detail the events leading from violent crime to capital punishment.[13]

Indexical like a photograph, the waxwork is inextricably linked to death. As a cast of its subject's own corporeal presence at one specific moment in time, the wax figure records for posterity an image of what once had been but no longer is. When a cast is made of a living person, it will forever embody the anterior future when, someday, the subject will no longer exist.[14] This reality is manifested in the fragile nature of wax itself, even when the material is pressed into the service of commemorative portraiture. And herein lies its essential cruelty.[15] Wax is far more delicate than human

skin; when cast, it can break apart or easily collapse. And as an isotropic substance, it will melt completely when exposed to heat. Though it can eerily resemble the translucency of living flesh, a waxwork is actually far closer to the body-as-corpse. The innate horror of this phenomenon is manifest in a work that Gordon has already produced in relation to this project entitled *Fragile hands collapse under pressure* (1999). After the initial casting of his body at the Musée Grévin, the wax copy of his hands actually fractured due (according to museum authorities) to the delicate nature of his own limbs. The artist then made a plaster cast of these inverted forms as a kind of treacherous memento mori.

Gordon exploits the frozen-in-time, abject quality of the wax figure in the new self-portrait project. Every year, on the same day, in the same place, he will photograph himself alongside his wax double. Intrigued by the concept of "photographing himself with himself," Gordon will be forced to confront the effects of time on his own appearance.[16] Unlike the mirror, which changes with us as we age, this wax mannequin will remain perpetually young. It will be the constant against which Gordon must measure and record his steady and irreversible drift toward old age and death. This is a fiendish inversion of Oscar Wilde's *The Picture of Dorian Gray* (1891), in which the protagonist retains his youthful beauty while his oil portrait bears the ravages of time. In this Faustian tale of narcissism, decadence, and the occult, Gray initially revels in his portrait's decrepitude. "He would examine with minute care, and sometimes with a monstrous and terrible delight, the hideous lines that seared the wrinkling forehead, or crawled around the heavy sensual mouth.... "[17] But, in the end, he succumbs to the horror of this black mirror, and by murdering the painting, he annihilates himself.

Gordon and his eternally youthful double as the years go by. The bond between them will no doubt be complex. What functions as an external reflection of the artist, as a duplication of his being, may also be read as the symbol for a self divided. This is the dialectic of the double. As Dr. Jekyll so painfully recognized about his own other contained within, "it was the curse of mankind that these incongruous faggots were thus bound together—that in the agonized womb of consciousness, these polar twins should be continuously struggling."[18]

Gordon stages this battle between self and internalized other in the two-channel video *A Divided Self I and II* (1996), in which two arms, one replete with hair, the other clean-shaven, are locked in a struggle for control. What is not immediately apparent is that both arms belong to the artist and it is he alone who is wrestling with himself. The source for such self-inflicted torment remains a mystery. Inner demons, split personality, unresolved guilt? This may be a scuffle between an individual and his doppelgänger, that self-same, shadowy other known to haunt the unassuming at moments of great inner darkness. It may also be a portrayal of a psychic breakdown, of a schizophrenic rupture that fragments the mind, leaving halves in place of a whole.

The title of this video piece, split onto separate monitors, recalls the Scottish psychologist R. D. Laing's pivotal and controversial treatise on mental illness, *The Divided Self: An Existential Study in Sanity and Madness* (1960). In Laing's view, standard medical discourse has served only to reify the distance between doctor and patient, codifying the distinction between reality and psychosis and defending the minds of the sane against the real experiences of the insane. These thoughts are echoed in Michel Foucault's nearly coeval study of the ways in which madness was isolated

A Divided Self I and II (detail), 1996
Video installation
Dimensions variable

from the rest of society through the imposition of rationalistic language during the Age of Enlightenment:

> In the serene world of mental illness, modern man no longer communicates with the madman: on one hand, the man of reason delegates the physician to madness, thereby authorizing a relation only through the abstract universality of disease; on the other, the man of madness communicates with society only by the intermediary of an equally abstract reason which is order, physical and moral constraint, the anonymous pressure of the group, the requirements of conformity. As for a common language, there is no such thing; or rather, there is no such thing any longer.... The language of psychiatry, which is a monologue of reason about madness, has been established only on the basis of such a silence.[19]

In our modern world of bipolar thought, art just may be the liberating force that fills the compulsory silence described by Foucault. A bridge between reason and madness, art can suspend the rational explanation, the logical conclusion, the theoretical given. In his evocation of Laing (a fellow Glaswegian), Gordon links together a specific tradition of primarily Scottish texts that embrace and articulate the experience of madness through the trope of the split personality.[20] His own work oscillates provocatively between an expression of this phenomenon and a contemplation of the occult.

Thematically, Gordon's art pivots on the semantic difference between splitting and doubling. While both words indicate a process of one becoming two, the former implies a rending in half, the latter a multiplication of form. In Gordon's metaphoric work, splitting may indicate the internal violence associated with psychic dissolution, which can in some circles be construed as liberating.

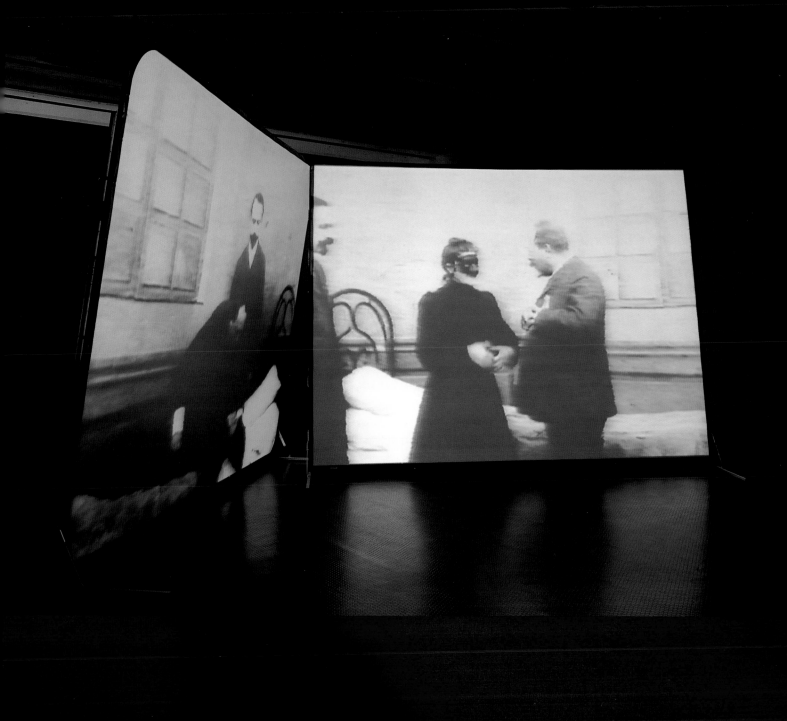

Hysterical, 1994/95
Video installation
Dimensions variable

And doubling may suggest the presence of supernatural forces on earth or at least the idea that the inexplicable is still plausible. It is within the indeterminate or liminal space between these two readings that the meaning of Gordon's art may be located.

The psychological experience of splitting (and doubling) is structurally emulated in Gordon's project through his physical manipulation of the moving image. Working as he does with existing film as a found object or readymade, he often duplicates projections so that they appear on two separate, free-standing screens, as in the case of *Hysterical* (1994/95) and *Confessions of a Justified Sinner* (1995–96). The installation *Hysterical*, for instance, uses turn-of-the-century medical footage demonstrating two doctors' treatment of a masked woman in the throes of a spasmodic interlude. One projection runs at standard speed, the other has been slowed to a crawl and reversed in a mirror reflection of itself. In its recuperation of the myths perpetuated by nineteenth-century psychoanalytic practice about women's sexual and mental health, the film reveals how psychic trauma can be inscribed directly on the body. But it also betrays its own artifice as a scenario staged for the camera, a fact heightened by Gordon's repetition and inversion of the imagery.

A more recent film installation, *through a looking glass* (1999), also investigates the conditions of psychic breakdown through a similar formal system of replication and opposition. Appropriating footage from one of the most often cited monologues in the history of cinema — Travis Bickle's "You talking to me?" sequence from Martin Scorsese's *Taxi Driver* (1976) — Gordon creates a dizzying spectacle of paranoia and aggression. The installation consists of a double-screen projection featuring Robert De Niro's famously improvised speech in front of a mirror, the deranged Bickle ranting at his own image and practicing his draw with a .44-Magnum gun. The

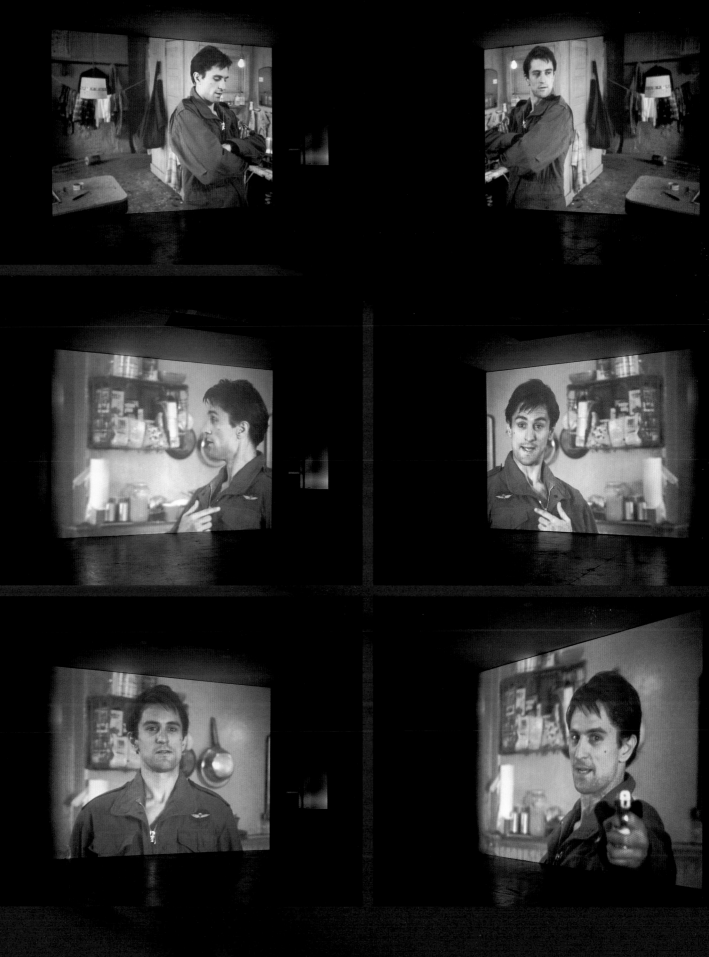

Stills from **through a looking glass**, 1999
Double video projection with sound
Dimensions variable

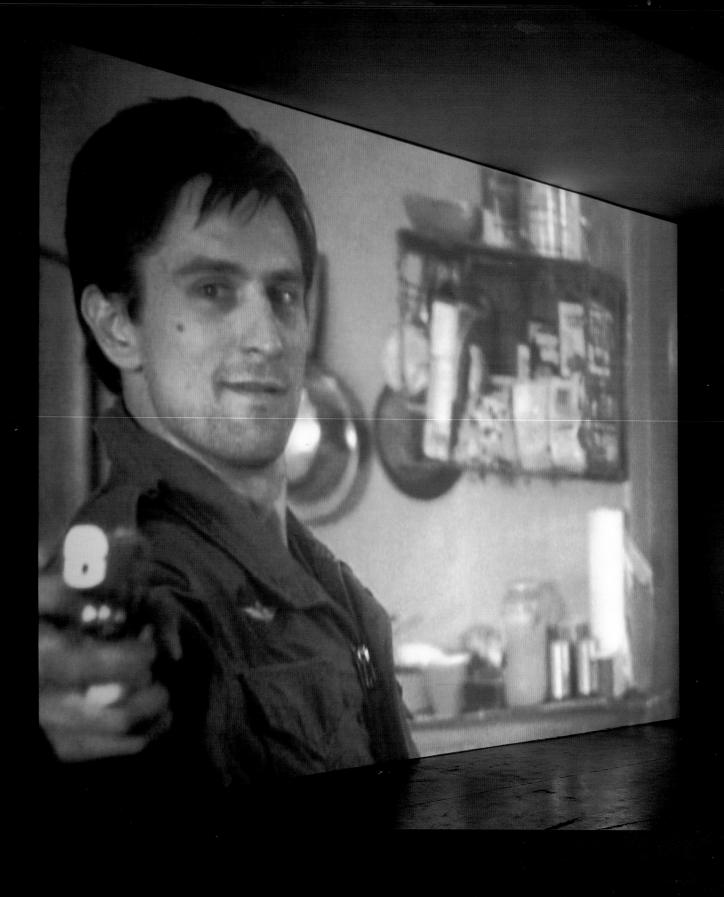

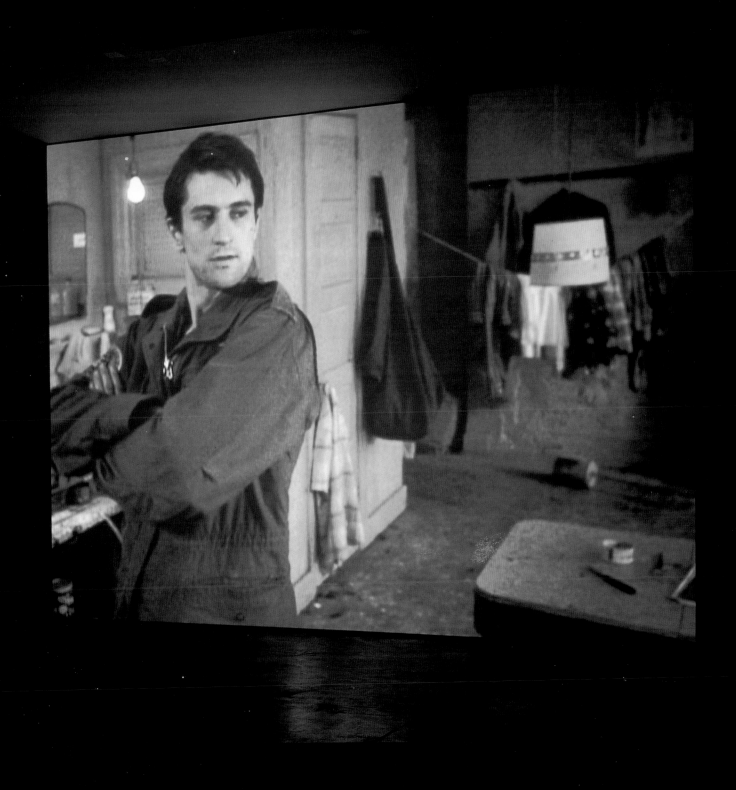

Stills from **through a looking glass**, 1999
Double video projection with sound
Dimensions variable

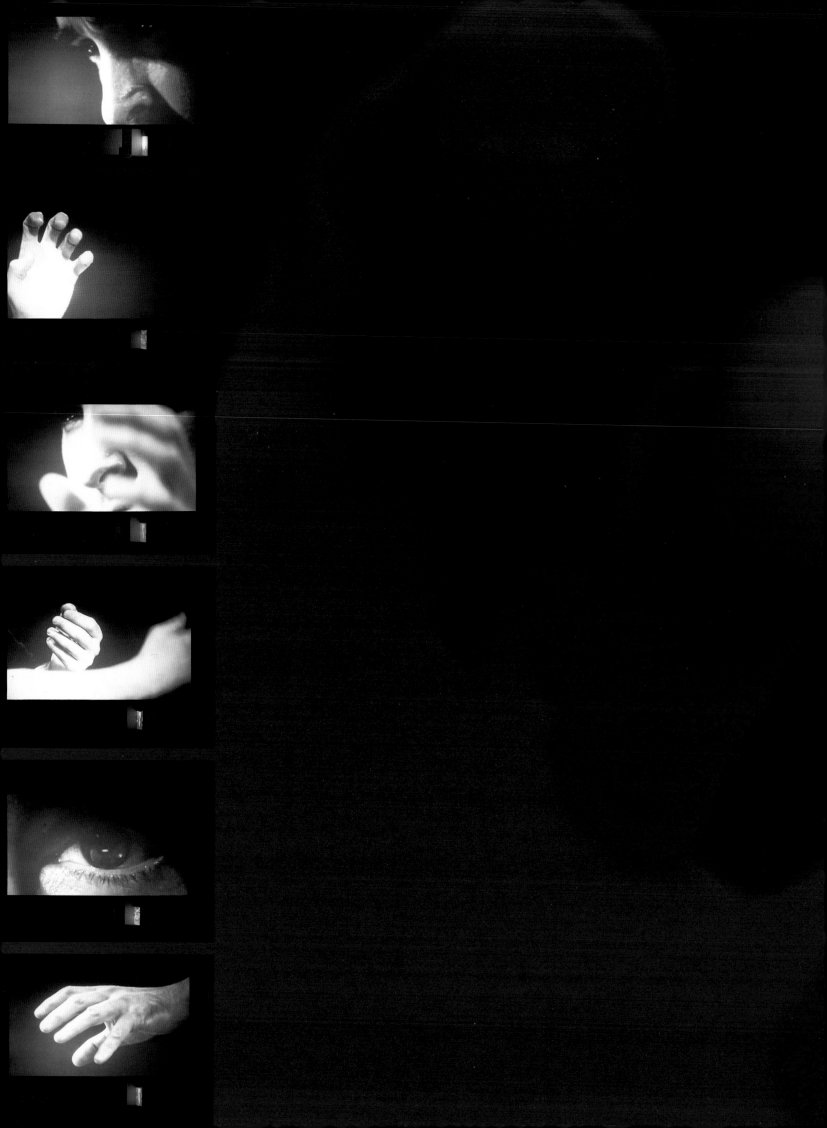

seventy-one second excerpt is duplicated and projected onto oppo-
site walls of the space, filling the room from floor to ceiling. One
of the projected images is flipped left to right to function as the
mirror image of the original clip. With each cycle of the excerpt,
the two images gradually go out of sync, an effect that further
parallels the character's emotional meltdown. The viewer stands
between these two monumental projections; at first he or she
inhabits the space of the mirror into which Bickle stares (which
is the space originally occupied by the camera). As the projections
lose their synchronization, Bickle appears to be having a conversa-
tion with his own double; words ricochet back and forth in a torrent
of manic questions and accusations: "Faster than you. Fuckass.
Saw you coming. Fucker. Shitheel. I'm standing here. You make
the move…. It's your move…. You talking to me? You talking to
me? Then who the hell else are you talking to?" As the two Bickles
aim their guns at one another, the viewer is caught in the crossfire.

Whereas Gordon has duplicated, protracted, and inverted his
films in order to complicate the cinematic gaze, he has also divided
the very substance of film into separate components.[21] In *Feature
Film* (1999), Gordon's directorial debut, he detached a soundtrack
from its attendant film, transforming the musical score into an
independent entity with a visual dimension all its own. Gordon's
film is a remake of Alfred Hitchcock's *Vertigo* (1958), that con-
summate tale of double identity, misplaced desire, and romantic
obsession. However, all one sees is a dramatically close-up view
of James Conlon, principal conductor of the Paris Opera, conduct-
ing Bernard Herrmann's score for the movie.[22] The orchestration
is perfectly synchronized with the timing of the dramatic narrative
so that moments of dialogue and action unaccompanied by music
are accounted for in Gordon's film with silence and succinct black
dissolves. The piece exists in three versions: a full-length 35-mm

film presented in a theater; an installation combining a projection of the film with a copy of *Vertigo* itself, which is shown in smaller scale with muted sound as a point of reference, a footnote, as it were; and, finally, as music on a CD recording.

In *Feature Film*, Gordon has unraveled two symbiotic cinematic elements, privileging the acoustic over the visual. At the same time, however, he has rendered the aural visible. Directed with a passion for cinematic effect and a faith in memory's narrative capacity, this work is not a deconstruction of Hitchcock's thriller. Rather, *Feature Film* is a cinematic séance. By splitting sound from image, Gordon teases forth the soul of the movie — which finds expression in Herrmann's ever-circular labyrinth of a score — and gives it new life.

In the installation *left is right and right is wrong and left is wrong and right is right* (1999), Gordon similarly disassembles the structural elements of film, but to a far different effect. Here he appropriates Otto Preminger's *Whirlpool* (1949), a noir mystery that pits the desublimating lure of psychoanalysis against the seductive authority of hypnosis in a story of insomnia, kleptomania, murder, and intrigue. Following the principle of division (and doubling), Gordon dissects the film by pulling apart its odd- and even-numbered frames and recasting them onto two separate reels. A simple line of black leader fills the gap remaining on each frame. When shown as two adjacent projections, the image on the left is reversed in a somewhat perverse déjà vu of its other. The soundtrack has been correspondingly fractured: dialogue, sound effects, and music from the partitioned frames have been split between separate speakers to create a stereophonic discord that defers but does not entirely mask meaning.

Cleaving this film at its most fundamental structural level, Gordon has rechoreographed the linear progression of the narrative

into a kind of chronological two-step. Every frame must encounter its twinned antecedent in a filmic analogue of the return of the repressed. Time flows forward only by moving back at a pace nearly invisible to the human eye. This temporal oscillation is manifest by intense stroboscopic palpitations that emulate the elision of tenses at the core of the installation and the psychic distress at the core of the original film.

The dual images in *left is right and right is wrong* seem to emanate from, if not circle around, the immobile, vertical seam that bisects (or connects) them. The effect is kaleidoscopic; as the twinned imagery moves in and out of focus, a Rorschachian blot metamorphoses along the central axis. This is a territory without language, substance, or form: it is the domain of the sub-liminal. What is this abyss but a rendering of the real — that hole in the midst of the symbolic order that in turn makes the symbolic order possible? Defined in Lacanian terms as a psychological kernel that erupts — often in the form of a traumatic return — to derail any sense of daily reality, the real actually structures this reality.[23]

According to Slavoj Žižek, fleeting glimpses of the real can be detected through a certain cinematic trope identified as *rendu*. Instead of operating through film's mimetic faculties or its capacity to represent through the symbolic codes of metaphor or metyn-omy, the *rendu* affects through a direct and immediate rendering of its content.[24] Here, the psychological substance of a film is not communicated by standard depiction, but rather through a very specific cinematic format that usually involves the deliberate obstruction of one of its key constitutive elements such as dialogue, montage, or the objective shot. In Gordon's installation — and in his oeuvre in general — the *rendu* is achieved through the persist-ent act of dividing and, by extension, doubling. Form equals content in the artist's ingeniously crafted, dualistic universe. Truth may be

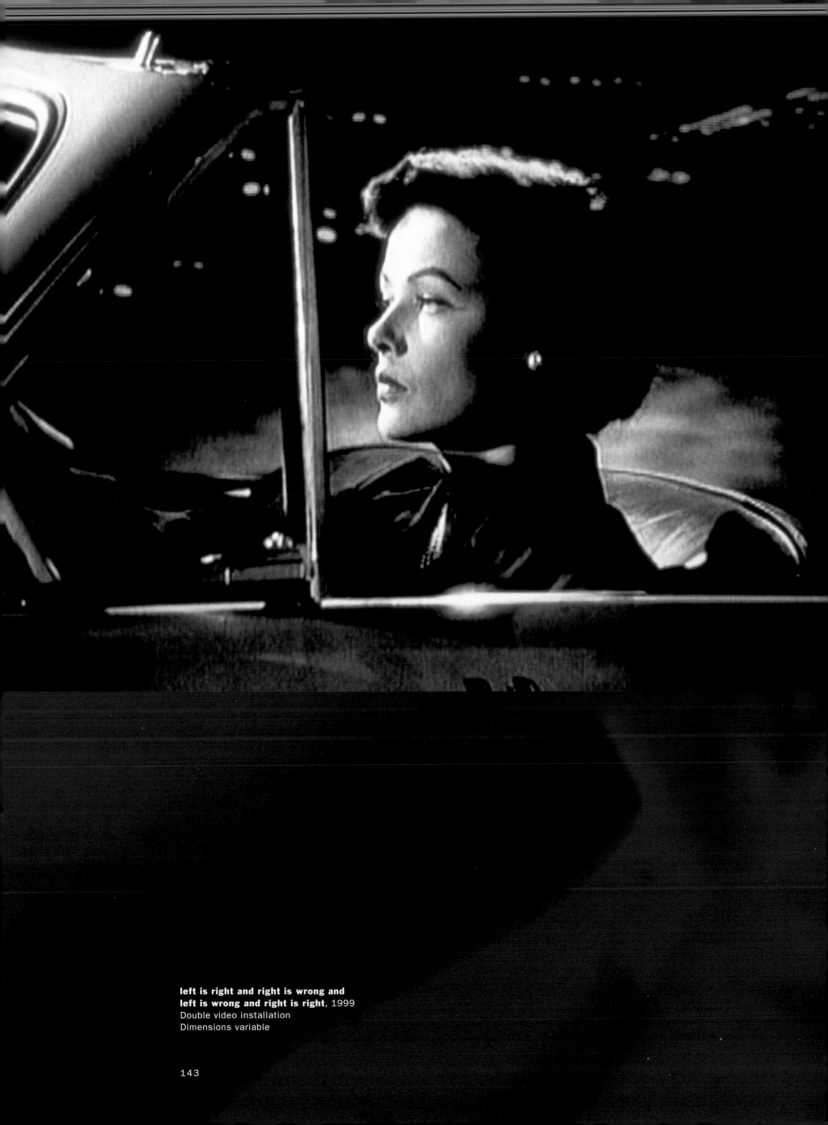

**left is right and right is wrong and
left is wrong and right is right**, 1999
Double video installation
Dimensions variable

more difficult to locate, however. Gordon's perpetual play of opposites derails any attempt at resolution. This art simply will never be one thing or the other. "The work," he once explained, "must be firmly ambiguous, moral and amoral, self-righteous in intent and self-denying in stature, communicating in tandem a desire for confession and a denial of responsibility, ethical but disruptive, acknowledging the status of people, belief systems, and power in our culture but refusing to acquiesce."[25]

1. In *Douglas Gordon • Black Spot* (Liverpool: Tate Gallery, 2000), 278. There are actually two email addresses included on this spread, the second being weir@hermiston.demon.co.uk, which refers to Robert Louis Stevenson's last and uncompleted novel *The Weir of Hermiston* (1896). Though also an important source for Gordon, this essay will focus more specifically on the significance of Hogg's book to the artist's work.

2. For a detailed analysis of Hogg's novel with particular attention to how the structure of the book mirrors its theme of dualism, see Douglas Gifford, *James Hogg* (Edinburgh: The Ramsay Head Press, 1976), 138–184. The motif of the double resonates throughout the literature of Scotland, which in itself is a country of schism, a nation historically divided by its allegiance to either the Catholic or Protestant Church and its long contested capitulation to the British crown. The prevalence of a strong Calvinist belief system and its preoccupation with the presence of evil on Earth also found expression in the metaphor of the doppelgänger, which informs some of the great Scottish novels, including Hogg's *Confessions*, and Robert Louis Stevenson's *The Strange Case of Dr. Jekyll and Mr. Hyde* (1886), *Kidnapped* (1886), and *The Weir of Hermiston*.

3. This was Gordon's response to a question about his references to doubling and the metaphor behind the video *A Divided Self I and II* (1996). See "… in conversation: jan debbaut and douglas gordon," in *Douglas Gordon: Kidnapping* (Eindhoven, The Netherlands: Stedelijk Van Abbemuseum, 1998), 49.

4. Sigmund Freud, "The Uncanny" (1919), in *Studies in Parapsychology*, ed. Philip Rieff (New York: Collier Books, 1963), 20.

5. Quoted in Nancy Spector, "This is all true, and contradictory, if not hysterical. Interview with Douglas Gordon," in *Art from the UK*, exh. cat. (Munich: Sammlung Goetz, 1997), 87.

6. See for example the letter to Martijn van Nieuwenhuyzen and Leontine Coelewij from the artist's brother, David Gordon, "by way of a statement on the artist's behalf," originally published in *Wild Walls*, exh. cat. (Amsterdam: Stedelijk Museum, 1995), n.p.; and reprinted in *Douglas Gordon • Black Spot*,

265–269; and the anonymously authored essay, "A Short Biography — by a friend.," originally published in *Douglas Gordon*, exh. cat. (Hannover: Kunstverein Hannover, 1998), n.p., and reprinted in *Douglas Gordon • Black Spot*, 361–368.

7. *Above all else ...* was originally installed as part of the Barclay's Young Artist Award exhibition at the Serpentine Gallery in London in 1991. The correspondence works are titled, respectively, *Letter 1* and *Instruction (Number 10c)*. They also exist as wall texts.

8. More recently Gordon acquired a two-part tattoo: the word "forever" is inscribed on both of his forearms; one applied with black ink and the other, which functions as a mirror image of the first, applied with white ink. As with *Tattoo (I)* and *Tattoo (II)* (both 1994), this tattoo was conceived as a work of art and entitled *Never, Never* (2000). Like the earlier piece, it functions as a double entendre. The pledge of "forever" can be a declaration of undying love, unquestioned faith, or unwavering allegiance, but it can also be a curse. Whatever it implies, there is no safe haven from its consequences. The dual meanings are embedded in the very structure of the tattoo, which splits and inverts the actual word.

9. Because it was never tied to specific codes of socialization, as is the case in other cultures, Western (particularly European) tattooing was defined historically by its mobility as a sign, connoting a range of possible meanings from the penal to the pious. According to Jane Caplan, the European tattoo was "a promiscuously travelling sign ... [that moved] literally on the homeless bodies of the slaves, criminals, pilgrims, sailors, soldiers and transported convicts." While today the tattoo is a popular symbol for subcultural status and even a fashion statement, its historical resonance would not have been lost on Gordon, whose approach to artmaking is unquestionably erudite. See Jane Caplan, ed., *Written on the Body: The Tattoo in European and American History* (Princeton, New Jersey: Princeton University Press, 2000), xv.

10. Quoted from "Oscar van den Boogaard talks with Douglas Gordon," in *Douglas Gordon*, exh. cat. (Lisbon: Centro Cultural de Belém, 1999), 41.

11. It is interesting to note in reference to this photograph Gordon's identification with Marcel Duchamp and Andy Warhol, who both photographed themselves in transgendered situations. Duchamp posed for Man Ray as his female alter ego Rrose Sélavy in the early 1920s, and Warhol created polaroids of himself in drag in 1981. In Gordon's "Short Biography," his friend recounts a tale about an incident in art school involving a murder. Just as a classmate of the artist is being led away by the police, the teacher gives Gordon two books. "'These are the books I told you about,' she says. 'It's probably about time you knew about them....' 'Thanks,' he says, as he looks at the names, MARCEL DUCHAMP, and ANDY WARHOL." *Douglas Gordon • Black Spot*, 365.

12. Robert Louis Stevenson, *The Strange Case of Dr. Jekyll and Mr. Hyde* (London: Penguin Books, 1979), 95.

13. This term was used by Umberto Eco in his amusing analysis of America's obsession with refabrications of the real. See "Travels in Hyperreality," in *Travels in Hyperreality* (San Diego: Harcourt Brace & Company, 1986), 10.

14. Photography's relationship to death has been poignantly articulated by Roland Barthes in his book *Camera Lucida*. Because a wax imprint is also an indexical sign, Barthes's meditations can be extended to an analysis of the wax figure's association with mortality. For Barthes, "the return of the dead" (9) is present in every photograph, each of which is an irreversible reminder that whatever was recorded by the camera no longer exists in the state pictured; the moment rendered is forever gone, save for a fading two-dimensional image. The snapshot cannot lie about the present or the past. It also unnervingly predicts the future. Perusing an old photograph of a young prisoner sentenced to death, Barthes notes that the man "is going to die," a reality inherent to all photography, a medium that simultaneously imparts the knowledge that "this will be" and "this has been." Barthes perceived in this photograph an "anterior future of which death is the stake," a past which is yet to come (96). See Barthes, *Camera Lucida: Reflections on Photography*, trans. Richard Howard (New York: Hill and Wang, 1981), 62, 110.

15. I am indebted here to Norman Bryson's analysis of the wax museum as a harbinger of modernism's fragmented self in his essay on Hiroshi Sugimoto's photographs. "The displeasure of the waxwork is always that of idealization thwarted: it is never realistic enough; it cannot deliver the goods; it is 'disappointing' in a deep sense, as though the waxwork's secret loyalty were not to the grand and unitary imago the ego strives for, but to the insidious undoing of that unity, that fusion of subject and image. Lurking just beneath the surface of the portrait waxwork is the sense of the body in pieces and the ego in fragments, not working as unity at all, not coming together as a human being — a sense of the human form melting or breaking from the inside and, as part of that, the half-emergence of an unpleasurable, sometimes hellish form, the body in mutilation and pain, the body expiring." Quoted from Bryson, "Everything We Look At Is A Kind Of Troy," in Tracey Bashkoff and Nancy Spector, *Sugimoto: Portraits* (New York: Solomon R. Guggenheim Foundation, 2000), 61.

16. In conversation with the artist, 10 March 2001.

17. Oscar Wilde, *The Picture of Dorian Gray* (1891), in *Complete Works of Oscar Wilde*, intro. V. Holland (London: Collins, 1976), 103.

18. Stevenson, *Dr. Jekyll and Mr. Hyde*, 82.

19. Quoted from Michel Foucault, *Madness and Civilization: A History of Insanity in the Age of Reason*, trans. Richard Howard (New York: Random House, 1965), x–xi. The reference to Foucault is indebted to Neville Wakefield's quotation from this source in his insightful essay on Gordon's work, "Lapse," in *Double Vision: Stan Douglas and Douglas Gordon*, exh. cat. (New York: Dia Center for the Arts, 2000), 32–43.

20. In response to the question "Who do you feel closest to in the art world?" Gordon provided a list of seventy-three names ranging from Lawrence Weiner to The Wooster Group to David Lynch. Among the names cited are James Hogg, Robert Louis Stevenson, and R. D. Laing, along with "The Devil." See Christine Van Assche, "Six Questions to Douglas Gordon," *Parachute*, no. 84 (October–December 1996): 18.

21. Gordon's found-film footage is actually transferred to video for its presentation in his installations and generally shown in continuous loops. But since the work so clearly references the cinema, I refer to his artwork as film throughout most of this text.

22. A veteran Hollywood composer, Herrmann wrote the scores to countless films, including Orson Welles's *Citizen Kane* (1941) and Alfred Hitchcock's *North by Northwest* (1959) and *The Birds*. Perhaps not inconsequential for Gordon, Herrmann also composed the soundtrack for *Taxi Driver* and the theme music for *The Twilight Zone*.

23. For a discussion of the real through literary and cinematic tropes—particularly through the work of Alfred Hitchcock—see Slavoj Žižek, *Looking Awry: An Introduction to Jacques Lacan through Popular Culture* (Cambridge, Mass.: The MIT Press, 1991).

24. Ibid., 40–43. In his discussion of *rendu*, Žižek refers to film theorist Michel Chion's definition of the term and cites the article "Révolution douce," in *La toile trouée* (Paris: Cahiers du Cinéma/Editions de l'Étoile, 1988). To support his argument Žižek also cites film theorist François Regnault's contention that the relation between content and form defines the entire Hitchcock opus: "the 'content' is always rendered by a certain formal feature (*Vertigo*: the spiral circles; *Psycho*: the intersected lines, etc.)." Žižek, *Looking Awry*, 174 n. 23.

25. Spector, "This is all true, and contradictory, if not hysterical," 87.

Following page
left is right and right is wrong and left is wrong and right is right, 1999

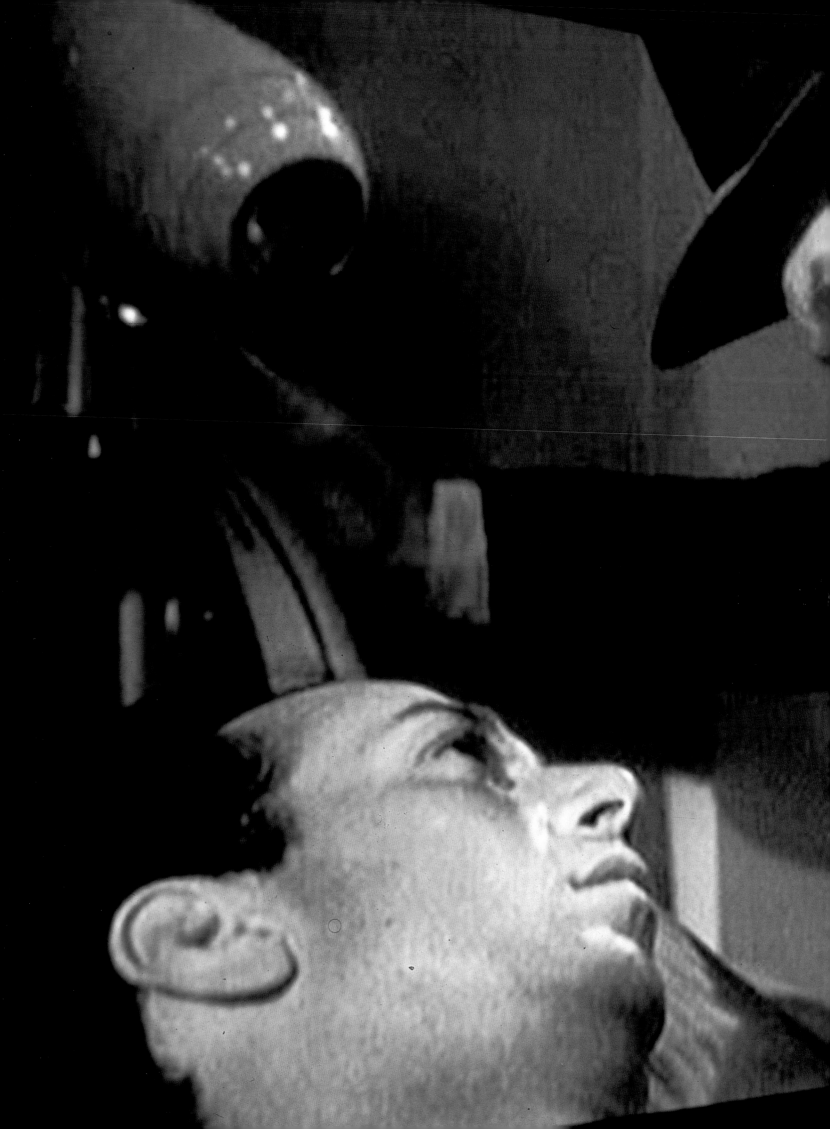

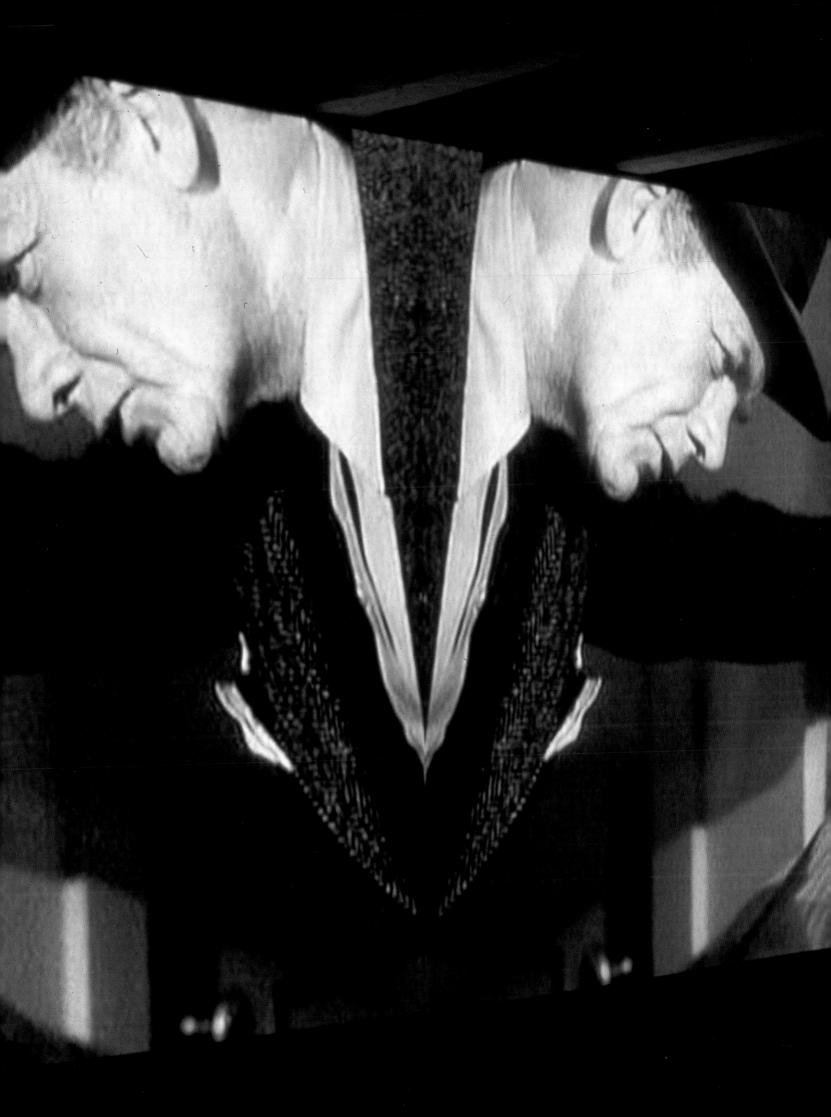

INTERVIEW WITH DOUGLAS GORDON
DAVID SYLVESTER

Sylvester What I'd like to do in this interview is to question you, not about the work you have produced, but about your attitude to an important part of its subject matter or raw material, namely film — or, to be precise, the commercial cinema. By the way, let me assure you that, if you choose to start talking about your own work, I shan't try and stop you. I'd like to begin by asking whether you look at art-house movies in the same way as or differently from Hollywood movies.

Gordon I think that ways of looking are determined more by the circumstances in which a film is seen than the commercial or "alternative" intent of the director. I try not to be too nostalgic about it but, to be quite honest, most of the movies that I've watched, I've watched in bed rather than in a cinema. For me there was no difference between seeing a Truffaut film late at night when I was sixteen in bed watching television, and watching a John Ford movie or a Huston movie in bed with my parents when I was maybe three, four, or five years old. It was not exactly the social context but the physical context of watching that knitted together all of my experiences. I've never been conscious of the difference between so-called art-house movies and Hollywood. They were either good films or bad films. The good ones are great and the bad ones you never want to see again. I'm never really conscious of the difference between the auteur and the artisan. Maybe I'm trying to be unconscious.

Sylvester The other day somebody told me about a lecture that they had been to where the lecturer was trying to demonstrate two different categories of movie-making. He took various themes and paired clips that exemplified opposing treatments of them. For example, one of his pairings began with the scene of Bardot dancing in *Et Dieu... créa la femme*. I interrupted my informant saying that the other must have been Karina dancing in *Vivre sa vie*. And of course it was. So there *is* a clear difference of attitude between Vadim and Godard, despite the fact that I, like you, would like there not to be.

Gordon Well I think that probably, in order to enjoy it or even not to enjoy it, one tries to minimize the difference between the one and the other. One of the problems that I had when studying at the Slade school was that I began to lose my enjoyment of cinema, something that had always been a very important part of my life. I like to call it enjoyment because it was time spent not doing something else — the classic idea of escape through cinema, an escape from other things. Towards the end of my two years at school, I ended up in a very strange situation where I was sharing a house in north London with other students from different departments of university college. One of them was a student psychiatrist, Nigel X, and when I moved into this house everyone else told me to beware of him because he would practice his interview technique on anyone who happened to be around at the time. After a few months of concentrated avoidance, I fell into his trap, of course. Late one night, after a good few beers, we were discussing music, books, films, and so on, and suddenly he made an observation. He noticed that I seemed to have enjoyed a lot of things up until the age of twenty-one or thereabouts. After this time, I began to qualify every choice of "favorite band" or "favorite film," rather than simply admit to liking the thing. Nigel identified this tendency as beginning at the time when I started my graduate studies in London. And this was, of course, the time when, if you were at art school, you got into a structuralist way of analyzing every fucking thing available. And I realized when I was going to the cinema at that time, I was actually thinking more about things that weren't on the screen — maybe the position of the camera, the sound engineer, or whatever extraneous aspect of filmmaking. Whatever. The bottom line was that I just couldn't enjoy it anymore. The idea of enjoyment just left me. I needed to get it back. Maybe this is why I'm saying that I tried not to see a difference between the intent of Godard and the intent of Vadim. I tried to compress them in order to enjoy them. I know that probably sounds a bit weak, but the theatricality of cinema is to do with enjoyment, to do with using the physical context in order to get out of another one in a way. The beauty of it for me is that you can sit there and watch absolute shit and think about something else

anyway. So for me the whole thing was a conduit through the screen and into somewhere else. It's always been like that for me. And this is maybe where, because art cinema is so dumb sometimes, it's easier to see right through what's on the screen and concentrate on what you really wanted to see all along. Sometimes the most boring films are the very best excuse you can find in order to think about an idea that's been burning a hole in your back pocket forever.

Sylvester What do you take as an example of dumbness in art cinema?

Gordon Godard. Maybe not the dumbness, but the beautiful blandness of it — especially from a British perspective. I've spent more time laughing at Godard than at Truffaut. Truffaut is comic and funny, beautiful. In a way the seduction of Truffaut for me is too much, it entraps me in the film. The blandness of Godard lets you go through it; it's that dumb.

Sylvester What were the first so-called art-house films that you recall having seen and recognized as being a different kind of film from Hollywood films? Were they French movies — the *nouvelle vague*?

Gordon I stumbled on them by accident when I was maybe fifteen or sixteen years old. I used to work on a late shift in a supermarket and when I came back home the clock was already at midnight or 1 A.M., and everyone in the house was already asleep, but I needed to rest and calm down before going to bed. This was around the time in Britain when Channel 4 had just started. It was a very very important thing: Channel 4 was the only thing on TV at that time of night. They ran a pretty esoteric film series, from what I can remember. And that's how I got to see Godard, that's how I got to see Truffaut, Rohmer, and everyone else. As well as the *vague* boys, I also got an introduction to B movies, and noirs — Nicholas Ray or Rudolph Maté or Otto Preminger, for example. These were the guys who had inspired the early *nouvelle vague* projects, too. This was where Godard and all that were coming from.

Sylvester But the B pictures themselves spoke to you?

Gordon Yes, much more than the films that were in cinemas at the time — things like *Star Wars*, *Jaws*, and whatever. They were

great films, of course, but not as influential for me as the movies I'd be watching at home. The cinema was much more of a controlled environment, whereas at home there were always some wise-cracks from your mum or dad, or someone on the telephone, or someone ad-libbing the next line or whatever. This happened more with film noir and B movies or Westerns than anything else. Our house was much more Sydney Greenstreet, John Wayne, and Barbara Stanwyck than Jean-Paul Belmondo and Jeanne Moreau. Or Steven Spielberg for that matter.

Sylvester I said I wasn't going to ask you questions about your work but I think this one could be allowed. Do you think that you have been using Hollywood films to make works of art? You wouldn't deny that the films you make are works of art?

Gordon No. I'll admit to that.

Sylvester And do you think that you use them in something of the same spirit in which the *nouvelle vague* directors used Hollywood films?

Gordon For different reasons, of course, but definitely, yes, absolutely. I stumbled across this idea that film noir had arrived in France after the war and the whole idea of blackness, which was as much to do with censorship as it was to do with the light effects that were involved. That was more interesting to me because of the whole issue in France, that these films represented something dangerous — as art and as a political vehicle. They represented a shift from the war, from being an occupied country, and so they were a sign for a possible future.

Sylvester Did you have a preference between gangster films and Westerns, or were you interested in both?

Gordon Westerns probably, because I got most of them through television. Westerns were always broadcast in the 60s and 70s, gangster films not so much. I got into them a little later.

Sylvester In the films that you have made you have clearly chosen subjects that gave you as much as possible to do.

Gordon I think when I started I wanted to use movies that were more important for the mythology around the film rather than the film itself. *Psycho* is the obvious one. Once again, this is to

do with the way I grew up with the film. I heard much more about it than I saw of it. The same would apply to Scorsese's *Taxi Driver*. It was talked about in school playgrounds for many years before I ever had a chance to see it. Sometimes the story told after an event can have more impact than being present at the event itself.

Sylvester And does that apply to *Vertigo*?

Gordon Absolutely. Even though I think *Vertigo* straddles the two kinds of films we have been talking about.

Sylvester The original is art house?

Gordon Yes. And pop. Both things at the same time.

Sylvester Is that Hitchcock's closest approach to art house and pop?

Gordon Absolutely.

Sylvester Is what interests you that it was both art house and pop?

Gordon I think originally it was just the pace of the film. It doesn't really work in the cinema and it certainly doesn't work on television. The idea of its not working was more interesting than *Psycho* in a way. The immediacy of the plot was gratifying but the constant denial of an ending all the way through was beautiful. Then at the end you still deny the moment of closure. "Things can't possibly end this way," we think. For me that made it absolutely not Hollywood cinema, and it even went beyond the best of the art-house stuff. Constant denial. How can you do that with James Stewart and Kim Novak? It's just two fingers in the face of every-body—that's what I love about it.

Sylvester Which version of *Feature Film* do you prefer? The version where you only see the conductor or the version where you also see the Hitchcock film? Because you've given both as performances.

Gordon I spoke to another artist about this—she had seen both versions—and she asked me: "Which is the definitive version?" My reply was that surely I worked fucking hard enough to make this thing live more than one life. Surely it shows that a desire for various edits of work means there is no need to be definitive.

Sylvester But you might have made two versions where neither was definitive and you still had a favorite?

Gordon I have a favorite, at least for the moment. That will probably change. But for now, I love the version that includes the projection of *Vertigo* in the same space as my *Feature Film*. That's my love, because it's confusing. I loved that when we showed it in London with a tiny *Vertigo* and a huge *Feature Film*, most people still watched the Hollywood version. Maybe that's perverse, but that's how it is. Even when we went to all this effort to make a film with a great conductor, a huge orchestra, expert sound and film crew, etc., people would still rather look at Kim Novak and James Stewart. They're compelled, in a way.

Sylvester But the silence enriched the film. The silence vastly enriched the film because it made it more artificial.

Gordon The various surfaces I used for projecting the images were very important in differentiating a reading of the two images. *Feature Film* was projected onto a large screen suspended in the room. Conlon's image was visible from both sides and physically dominated the entire space. Even when the projector was switched off, the screen itself had a presence that competed with the existing architecture. *Vertigo*, however, was projected onto a nearby wall. The image was much smaller and there was no sound. It felt as though the image could be wiped away, as if, when the projector was switched off, the film had never existed. The original architecture bore no trace of the image that had just been there, seconds before. This made a huge difference in the perception of both images, the difference between a screen and a wall. Beyond the wall was nothing, but with a screen you always have another side. You know there's something on the other side of the screen, whether it's fiction or reality.

Sylvester So you reverted again to the importance of the physical experience of looking at the film as crucial — back to the experience of sitting up in bed, rather than in the cinema. And again one's awareness of the projection on a wall is different from the projection on a screen. So the physical reality of film is as important to you as it is for a painter, whether working in fresco or whether working in oil on canvas.

Gordon Even more than that. I watched a documentary on Picasso recently where they were talking about the different treatments that he would apply depending on who the sitter was and the relationship with the sitter. For me, it depends who you're lying in bed with, how you receive a film. It's not just that you're outside of cinema. This is an odd thing for my generation: you are aware that films are made for cinema, but you are more likely to watch them at home. If you're lucky you watch them in the bedroom; if you're very, very lucky you're in bed watching with someone. But this other person that you're with and what you're doing with them absolutely affects the way you perceive images and the way you perceive sound. It just seems normal to me to imagine that we've all watched the same film with different peopl and it absolutely changes the way you read the film. And, maybe more importantly, how you remember the film.

Sylvester I haven't forgotten that when I first saw *Citizen Kane* one afternoon in 1941, sitting at the back of the stalls in an empty West End cinema, it was already reputed to be a cinematic masterpiece, but I was simultaneously undressing a girl I had jus picked up in a bar.

Gordon Next time I see that film I'm going to think of you doing that. That's the social aspect of film, the social aspect of the perception of film. I'm interested in it because it's beyond defini-tion. You just told me this story; now it is in my head and I'm goir to build it into my next experience of the film. This is a crucial difference between cinema and other art forms — it's constantly moving and building. Most people don't watch movies on their own. When you think about going to a museum to look at a paint ing or a sculpture, there are usually other people there, but you usually don't talk to them and you're certainly not lying in bed wit them. It's funny that there's an ironic kind of intimacy around a medium that is commercially so vulgar sometimes. It's like the worst possible way to get an idea across, because you have to work with so many other people and compromise so many times but it's extremely intimate when it comes out the other end. With other art forms it's quite the opposite, it's an extremely intimate

process. You have a solitary painter or solitary sculptor and then it's put into the museum with lots of people milling round. I love that.

Sylvester When was your first experience of silent pictures? Or maybe it wasn't crucial for you?

Gordon But there are no silent pictures, because the silence is always filled with something.

Sylvester What about the piano that accompanied the old silent movies?

Gordon The first time I saw a film with a piano player was in Glasgow in 1986/87 and once again it was a Hitchcock film, *The Lodger*, which has become more of an art film for me than *Vertigo*. I've only ever seen the film once on a big screen. I happened to be with a very special person at the time, and there was a piano player. There is one scene when the lodger – who is supposed to be Jack the Ripper or whatever – is upstairs and is walking across the floor. The beautiful young daughter of the landlord is downstairs. As far as I can remember, she's also deaf. So even though she cannot possibly hear the footsteps of the lodger, she looks up at the ceiling, which is immediately a beautiful flaw. The way Hitchcock shot it was amazing. He used a glass floor and ceiling, and you can see the lodger's feet moving across space. It's about deafness and blindness and the fact that the piano player is unnecessary.

Sylvester There is also a classic kind of Western music, which is very strong in *The Searchers*. The score in *The Searchers* was very important. Would you agree with me?

Gordon Because nothing happens in the movie, something has to take you from one scene to another and the music does this. I always associate *The Searchers* with another film, *Ben Hur*, because of the desert scenes. The desert obviously is a metaphor for nothingness, no growth, and a spiritual wilderness. The music in *Ben Hur* is much more apparent than in *The Searchers* where it just becomes part of the landscape – like it doesn't exist in a way. I don't even know who wrote the score for *The Searchers*. It just fades in and takes you across the desert.

Sylvester Was the fact that nothing much happens in *The Searchers* what attracted you to using it?

Gordon I've no idea how many times I saw the film, but I do remember my confusion about *The Searchers* started when I was a child. It wasn't like a regular Western, because nothing much happens. I used to ask my father why there was not more action, and he continually told me that the nothingness was what it was all about. And the older I got the more confused I became. Eventually, I began to come to some kind of understanding of the thing. Maybe now I think there's too much action — or perhaps I'm just getting old.

Sylvester At the time *The Searchers* came out I never missed a new Western and I thought it was (a) the best Western I had ever seen and (b) by far the best Ford film I had ever seen. I said to the person I was with: this is Ford's best movie and the *Sight and Sound* reviewers are going to say that it's no good and that *Stagecoach* was twenty times better, and it shows how little they know, because *Stagecoach* is pure kitsch.

Gordon Yes it's vaudeville, absolute vaudeville. There's no pace.

Sylvester You talked about there being more art in *Vertigo* and in *The Lodger* and in other Hitchcock films. Was there more art in *The Searchers* than in other Ford films such as *My Darling Clementine*, *She Wore a Yellow Ribbon*, and so on?

Gordon I know what you're saying, but I don't think it's an art issue. There's not any more art in *Vertigo* than in other movies, but there is more denial of the traditional cinematic "treat."

Sylvester There's more denial of the cinematic treat?

Gordon Most people go to the cinema to be entertained, which is different from enjoyment. I think there is really a critical difference between entertainment and enjoyment.

Sylvester Tell me what the difference is.

Gordon Entertainment gives you an end, an ending — but enjoyment goes on long after. Enjoyment is in your head but entertainment stops when the curtain closes. Enjoyment can be when you go to sleep and remember things, when you're falling asleep and when you're waking up, your reflection, and your memory. This may be to do with the way I was brought up, falling asleep thinking about

the day before and waking up thinking about the day ahead. But t
go back to *The Searchers*, it's no more arty than other Westerns
The most arty Western was *High Noon*, because it's in real time.
And it's beautiful for that.

Sylvester You use the word "arty." Is it in the pejorative sense?

Gordon No.

Sylvester You simply mean artistic?

Gordon Yes.

Sylvester Because to me the arty Western in the pejorative
sense is *Shane*.

Gordon For me *Shane* is a beautiful film in a pop sense. I don't
think it's arty pejorative at all. It's a beautiful film because it's pop
absolutely pop, because ... it's a children's film. If it was made
now, it would be made by Disney and it would probably be animated
and the only thing that you or I even would remember from it is
what we still remember: the kid calling out the hero's name at the
end. It would boil down to that. "Shane! Shane! Shane!"

Sylvester You've defined the difference between entertainmen
and enjoyment; what's the difference between entertainment
and art?

Gordon I hope that art, like enjoyment, doesn't stop. Even the
most disturbing art is always enjoyable.

Sylvester If I may, I'll give you a definition I once arrived at of
the difference between art and entertainment. The entertainer
is like the rhetorician: he wants to achieve certain effects, which
he is aware of wanting to achieve, and his mastery of the medium
includes knowing exactly the effects he wants. The artist does not
know what he wants to achieve. He goes into the thing with the
desire to explore the subject matter and see what happens. So
the artist comes out of creating a work knowing more than he di
about the subject, whereas the entertainer has not learnt anything
about the subject by doing the work though he may have learned
something about his craft. And I always considered Hitchcock to be
an entertainer.

Gordon Absolutely — he knew exactly what he was doing. One
can be probably absolutely derogatory towards Godard, but the

beauty of Godard is the blandness, putting things out when you've no idea what the reception can be. And that's why he is important, as much as Hitchcock, in any case.

Sylvester So you would agree that there is a difference between …

Gordon Absolutely. You know the film *The Entertainer* with Laurence Olivier? That film illustrates the point quite bluntly. Olivier's character has one kind of life off-stage, where he goes around fucking whoever he wants in an amoral kind of landscape he has made for himself. But when it comes to "entertaining," he stops misbehaving, goes on stage and does his job, receives applause, and then gets back down to the nasty business of his life when the curtain closes. He's a star.

Sylvester Are you interested in stars?

Gordon Only in the mythology around them. I don't want to meet them. They do have a place in the world, and an important one at that. When I talked to you about Hitchcock's *Vertigo* and the constant denial of a logical narrative, a constant denial of an ending, these are the sort of elements that are supposed to stop people watching films. But the film is carried on the fact that people want to watch James Stewart, and more than that, Kim Novak. The viewer need not become a slave to the star by any means. The star can be used as an alibi for thinking thoughts that seem impossible in a humdrum life. As Kenneth Anger said, stars are like gods — you need gods in order to think about other things. That shouldn't be the privilege or the job of artists only.

Every Man and every Woman is a star.
— Aleister Crowley quoted in Kenneth Anger's *Hollywood Babylon*

SELECTED BIBLIOGRAPHY

Monographs

Déjà-vu: Questions & Answers. 3 vols. Paris: Musée d'Art Moderne de la Ville
 de Paris, 2000.

Douglas Gordon. Exh. cat. Hannover: Kunstverein Hannover, 1998.

Douglas Gordon. Exh. cat. Lisbon: Centro Cultural de Belém, 1999.

Douglas Gordon • Black Spot. Exh. cat. Liverpool: Tate Liverpool, 2000.

Douglas Gordon: Close Your Eyes, Open Your Mouth. Exh. cat. Zürich: Museum
 für Gegenwartskunst, 1996.

Douglas Gordon: Kidnapping. Exh. cat. Eindhoven, The Netherlands: Stedelijk
 Van Abbemuseum, 1998.

Douglas Gordon: through a looking glass. Exh. cat. New York: Gagosian Gallery, 1999.

Entr-Acte 3, Douglas Gordon. Exh. cat. Eindhoven, The Netherlands: Stedelijk
 Van Abbemuseum, 1995.

Feature Film: A Book by Douglas Gordon. Exh. cat. London: Artangel; London:
 Book Works; and Paris: agnès b., 1999.

24 Hour Psycho: Hitchcock's Tomb. Exh. cat. Glasgow: Tramway, 1993.

Reviews and Essays

Archer, Michael. "Collaborators." Art Monthly, no. 178 (July–August 1994): 3–5.

———. "Home and Away." Art Monthly, no. 188 (July–August 1995): 98.

Bezzola, Tobia. "De Spectaculis, Or Who Is Kim Novak Really Playing?" Parkett,
 no. 49 (May 1997): 52–57.

Blazwick, Iwona. "Douglas Gordon." Art Monthly, no. 183 (February 1995):
 34–36."In Arcadia." Art Monthly, no. 209 (September 1997): 7–10.

Bishop, Claire. "Douglas Gordon: Are You Looking at Him?" Flash Art 32, no. 207
 (Summer 1999): 102–105.

The British Art Show 4. Exh. cat. London: The South Bank Centre, 1995.

Brougher, Kerry, et al. Art and Film Since 1945: Hall of Mirrors. Exh. cat.
 Los Angeles: The Museum of Contemporary Art; and New York: The Monacelli
 Press, 1996.

Brown, Katrina M. "Sawn Off." Art Monthly, no. 196 (May 1996): 40–43.

Buck, Louisa. "Silver Scene." Artforum 34, no. 10 (Summer 1996): 34–36.

————. "Douglas Gordon's Directorial Debut." *The Art Newspaper*, no. 91 (April 1999): 14.

Camhi, Leslie. "Very Visible…and Impossible to Find." *ARTNews* 98, no. 7 (Summer 1999): 142–145.

Curtis, Sarah. "Take Me (I'm Yours)." *World Art*, no. 3 (Summer 1995): 98.

Decter, Joshua. "New York in Review: Walk On." *Arts Magazine* 66, no. 4 (December 1991): 82–83.

Double Vision: Stan Douglas and Douglas Gordon. New York: Dia Center for the Arts, c2000.

Drobnick, Jim. "Reveries, Assaults, and Evaporating Presences." *Parachute*, no. 82 (January–February–March 1996): 10–19.

Feaver, William. "Douglas Gordon at Lisson." *ARTNews* 94, no. 3 (March 1995): 144.

Feldman, Melissa E. "21 Days of Darkness." *Art Monthly*, no. 195 (April 1996): 38–40.

Ferguson, Russell. "Divided Self." *Parkett*, no. 49 (May 1997): 58–63.

Findlay, Judith. "Glaswegian Goods." *Flash Art* 29, no. 188 (May–June 1996): 64.

Flood, Richard. "24 Hour Psycho." *Parkett*, no. 49 (May 1997): 36–39.

Freedman, Carl. "Take Me (I'm Yours) at Serpentine Gallery, London." *Frieze*, no. 23 (Summer 1995): 73–74.

General Release: Young British Artists at Scuola di San Pasquale. London: British Council, 1995.

Gillick, Liam. "The Corruption of Time: Looking Back at Future Art." *Flash Art* 29, no. 188 (May–June 1996): 69–70.

Glover, Michael. "Spellbound: Art and Film at Hayward Gallery." *ARTNews* 95, no. 6 (June 1996): 158–159.

Gordon, Douglas. "Lost, then found, then lost again: a true story, after Samuel Beckett," 179–183. *Witte de With – Cahier #2*. Rotterdam: Witte de With; and Düsseldorf: Richter Verlag, 1994.

Gordon, Douglas, and Liam Gillick. "Les infos du paradis." Collaboration for *Parkett*, no. 44 (July 1995): 197–201.

————. "Sailing Alone Around the World: A correspondence between Douglas Gordon and Liam Gillick." *Parkett*, no. 49 (May 1997): 73–76.

Groys, Boris. "Douglas Gordon at Kunstverein Hannover." *Artforum* 37, no. 6 (February 1999): 90–91.

Guilt By Association. Exh. cat. Dublin: Irish Museum of Modern Art, 1992.

Higgie, Jennifer. "Douglas Gordon at Atlantis, London." *Frieze*, no. 48
 (September–October 1999): 97.

The Hugo Boss Prize. 1998. New York: Guggenheim Museum, 1998.

Kingston, Angela. "Douglas Gordon at Lisson Gallery, London." *Frieze*, no. 21
 (March–April 1995): 60–61.

Lawson, Thomas. "Hello, It's Me." *Frieze*, no. 9 (March–April 1993): 14–17.

Lowry, Joanna. "Spellbound." *Creative Camera*, no. 339 (April–May 1996):
 40–41.

McArthur, Euan. "Sites/Positions." *Artscribe* (Summer 1990): 77–78.

Maloney, Martin. "Douglas Gordon at Lisson." *Flash Art* 28, no. 182 (May–June
 1995): 114.

Manifesta 1. Exh. cat. Amsterdam: Idea Books, 1996.

McEvilley, Thomas. "Seeing Double." *Interview* (April 1999).

Migrateurs: Douglas Gordon. Exh. cat. Paris: Musée d'Art Moderne de la Ville de
 Paris, 1993.

The Missing Text. Sight Works, vol. 2. London: Chance Books, 1991.

Moisdon-Trembley, Stéphanie. "Douglas Gordon, 'Attraction-répulsion.'" *Blocnotes*,
 no. 11 (January–February 1996): 46–53, 109–115.

Newhall, Edith. "Walk On at Jack Tilton." *ARTNews* 90, no. 9 (November 1991):
 147.

Newman, Michael. "Beyond the Lost Object: From Sculpture to Film and Video."
 Art Press, no. 202 (May 1995): 45–50.

Prospect 93: An international exhibition of contemporary art. Exh. cat. Frankfurt:
 Frankfurter Kunstverein, 1993.

Renton, Andrew. "Douglas Gordon at Tramway." *Flash Art* 26, no. 172 (October
 1993): 92.

Saltz, Jerry. "Up and Down." *The Village Voice*, 30 March 1999.

Sans, Jérôme. "Douglas Gordon at Centre Georges Pompidou." *Artforum* 34, no. 8
 (April 1996): 109–110.

Schambelan, Elizabeth. "Douglas Gordon at Gagosian." *Art in America* 89, no. 5
 (May 2001): 169.

Self Conscious State. Exh. cat. Glasgow: Third Eye Centre, 1990.

Sinclair, Ross. "Douglas Gordon." *Art Monthly* (June 1993): 22–23.

Sladden, Mark. "Spellbound: Art and Film." *Art Monthly*, no. 195 (April 1996):
 25–27.

Spellbound: Art and Film. Exh. cat. London: British Film Institute and Hayward Gallery, 1996.

Stain in Reality: Stan Douglas, Douglas Gordon, Joachim Koester. Exh. cat. Copenhagen: Galleri Nicolai Wallner, 1994.

33 1/3. Exh. cat. Canberra, Australia: Canberra Contemporary Art Space, 1996.

The Turner Prize 1996. Exh. cat. London: Tate Gallery, 1996.

Van Assche, Christine. "Six Questions to Douglas Gordon." *Parachute*, no. 84 (October–November–December 1996).

Viennese Story. Vienna: Wiener Secession, 1993.

Volkart, Yvonne. "Douglas Gordon at Museum für Gegenwartskunst, Galerie Walcheturm." *Flash Art* 30, no. 195 (Summer 1997): 145–146.

Wall To Wall. Exh. cat. London: The South Bank Centre, 1994.

Walk On: Six Artists from Scotland – Craig Richardson, Kevin Henderson, Douglas Gordon, Karen Forbes, Graeme Todd, Angus Hood. Exh. cat. New York: Jack Tilton Gallery, 1991.

Whyte, Ryan. "Douglas Gordon: The Power Plant, Toronto." *Artext*, no. 72 (February–April 2001): 83.

Wild Walls. Exh. cat. Amsterdam: Stedelijk Museum, 1995.

Windfall 89: Das Bunkerskulptur Projekt in Bremen. Exh. cat. Bremen: Girzig and Gottschalk, 1990.

Windfall '91. Glasgow: Seaman's Mission, 1991.

WORKS IN THE EXHIBITION

Psycho Hitchhiker, 1993
Black-and-white photograph
18 × 23½ inches
Collection of Sean and Mary Kelly,
New York

A Souvenir of Non-Existence, 1993
Framed letter, envelope, and
black-and-white photograph
25 × 47¼ inches
Courtesy of Lisson Gallery, London

10ms⁻¹, 1994
Video installation
Dimensions variable
Courtesy of Tate Gallery, London

24 Hour Psycho, 1993
Video installation
Dimensions variable
Collection of the Kunstmuseum
Wolfsburg

Tattoo (I), 1994
Black-and-white photograph
53 × 34¾ inches
Private collection

Tattoo (II), 1994
Black-and-white photograph
53 × 34¾ inches
Courtesy of Lisson Gallery, London

Trigger Finger, 1994
Video installation
Dimensions variable
Goetz Collection, Munich

B-Movie, 1995
Video installation
Dimensions variable
Goetz Collection, Munich

Film Noir (Fly), 1995
Video installation
Dimensions variable
Courtesy of Lisson Gallery, London

Film Noir (Hand), 1995
Video installation
Dimensions variable
Courtesy of Lisson Gallery, London

Film Noir (Perspire), 1995
Video installation
Dimensions variable
Courtesy of Lisson Gallery, London

5 Year Drive-By, 1995
Video Installation
Dimension variable
Screening at 29 Palms Inn
Twentynine Palms, California
22 September 2001

A Divided Self I and II, 1996
Video installation
Dimensions variable
Fondazione Sandretto Re
Rebaudengo per l'Arte, Turin

*Selfportrait as Kurt Cobain, as
Andy Warhol, as Myra Hindley, as
Marilyn Monroe*, 1996
C-print
30½ × 30½ inches
Collection of Audrey Irmas,
Los Angeles

30 Seconds Text, 1996
Text on black wall, timing device,
and light bulb
Bembo and Helvetica typefaces
Goetz Collection, Munich

Monster, 1996–97
Transmounted C-print
37½ × 50 inches
Collection of Eileen and Peter
Norton, Santa Monica

*Between Darkness and Light (After
William Blake)*, 1997
Video installation
Dimensions variable
Courtesy of the artist and Lisson
Gallery, London

Tattoo (for Reflection), 1997
C-print
22½ × 23¼ inches
Collection of Cari and Max Lang,
New York

Three Inches (Black), 1997
Eleven color photographs
Seven photographs, 31¾ × 41½
inches each; two photographs
31¾ × 36¾ inches each; one
photograph, 31¾ × 48½ inches;
and one photograph,
31¾ × 36¾ inches
Collection of Yvon Lambert, Paris

Blue, 1998
Video installation
Dimensions variable
Private collection

Feature Film, 1999
35-mm film
Dimensions variable
Screening at the American
Cinematheque, Los Angeles
16 September 2001

*Fragile hands collapse under
pressure*, 1999
Wax
10 × 5 × 3 inches
Collection of the artist
Courtesy of Yvon Lambert, Paris

through a looking glass, 1999
Double video projection with
sound
Dimensions variable
Courtesy of Solomon R.
Guggenheim Museum, New York

Black Spot, 2000
Digital C-print
40 × 30 inches
Collection of Mark and Vanessa
Mathysen-Gerst
Courtesy of Gagosian Gallery,
New York

Black Spot Negative, 2000
Digital C-print
40 × 30 inches
Collection of Mark and Vanessa
Mathysen-Gerst
Courtesy of Gagosian Gallery,
New York

croque-mort, 2000
Digital C-print
54 × 37¼ inches
Collection of Rita Krauss
Courtesy of Gagosian Gallery,
New York

croque-mort, 2000
Digital C-print
54 × 37¾ inches
Collection of Andrea Fortunoff
Courtesy of Gagosian Gallery,
New York

croque-mort, 2000
Digital C-print
37¼ × 54 inches
Collection of Jerome Stern
Courtesy of Gagosian Gallery,
New York

croque-mort, 2000
Digital C-print
54 × 37¼ inches
Courtesy of Lisson Gallery, London

croque-mort, 2000
Digital C-print
54 × 37¼ inches
Collection of Sabine Walli
Courtesy of Gagosian Gallery,
New York

croque-mort, 2000
Digital C-print
37¼ × 54 inches
Courtesy of Gagosian Gallery,
New York

croque-mort, 2000
Digital C-print
54 × 37¼ inches
Courtesy of Gagosian Gallery,
New York

Déjà vu, 2000
Triple video projection
Dimensions variable
Courtesy of Gagosian Gallery,
New York

Never, Never, 2000
Two digital C-prints
24 × 30 inches each
Collection of Erik and Heidi
Murkoff, Montecito

PHOTO CREDITS

FILM ACKNOWLEDGMENTS

Stills from the following films appear in illustrations of works by Douglas Gordon:

From *Psycho*, 1960, dir. Alfred Hitchcock, Universal Studios © Universal, pp. 16–18; from *The Searchers*, 1956, dir. John Ford, Warner Bros. Studios © Warner Home Video, pp. 36–37; from *The Song of Bernadette*, 1943, dir. Henry King, 20th Century Fox © Criterion Pictures, pp. 40–41; from *The Exorcist*, 1973, dir. William Friedkin, Warner Bros. Studios © Warner Home Video, pp. 40–41; from *D.O.A.*, 1950, dir. Rudolph Maté, Cardinal Pictures © Reel Media International, p. 49; from *Taxi Driver*, 1976, dir. Martin Scorsese, © 1978 Columbia Pictures Industries, Inc. All rights reserved. Courtesy of Columbia Pictures, pp. 72 left, 135–37; from *Dr. Jekyll and Mr. Hyde*, 1931, dir. Rouben Mamoulian, Paramount Pictures © Metro Goldwyn Mayer/United Artists, p. 116; and from *Whirlpool*, 1949, dir. Otto Preminger, 20th Century Fox © Criterion Pictures, pp. 142–43, 150–51.

The following correspond to the film stills used to illustrate "Interview with Douglas Gordon" by David Sylvester and appear courtesy of The Museum of Modern Art Film Stills Archive, New York:

From *Bigger Than Life*, 1956, dir. Nicholas Ray, pp. 152–53; from *Vertigo*, 1958, dir. Alfred Hitchcock, pp. 154–55; from *La mariée était en noir* (The Bride Wore Black), 1967, dir. François Truffaut, pp. 156–57; from *Double Indemnity*, 1944, dir. Billy Wilder, pp. 158–59; from *They Live By Night*, 1948, dir. Nicholas Ray, pp. 160–61; from *White Heat*, 1949, dir. Raoul Walsh, pp.162–63; from *Tirez sur le pianiste* (Shoot the Piano Player), 1960, dir. François Truffaut, pp. 164–65; from *À bout de souffle* (Breathless), 1962, dir. Jean-Luc Godard, pp. 166–69; from *Les quatre cents coups* (The 400 Blows), 1959, dir. François Truffaut, pp. 170–71; and from *Citizen Kane*, 1941, dir. Orson Welles, pp. 172–73.

douglas gordon would like to thank the following people for help and support, usually above and beyond...

anna kristine, fergie and karin, taylor's steak house, rodney's oysters, tom and susan, big john b., trusty bert, wee nancy, tom e., kerry b., pilar, nicholas, barry-b., tally-ho kay, the roughster, mr. wingate, brother zach, the moca tech crew — brian, zazu, david, jang — miss mark, amanda seabreeze, catherine t-rix, big bruce, mollie d-b., count stefan, doctor frank, jim, mary, andrew, dave, jan and catherine-croque-mort, doctor ron, noah g., sean and mary, the darling, equipe lambert — yvon, martine, olivier, elodie, gilles — wee jan d., big larry, big rich and sarah, susan c., p-p (the big man), bernard and marie, eileen and michael, leonard and susan, cecily and david.

DOUGLAS GORDON

This publication accompanies the exhibition "Douglas Gordon," organized by Russell Ferguson, and presented by The Museum of Contemporary Art, Los Angeles, 16 September 2001 – 20 January 2002.

"Douglas Gordon" is made possible in part by Susan Bay-Nimoy and Leonard Nimoy, Catharine and Jeffrey Soros, The Thorton S. Glide, Jr. and Katrina D. Glide Foundation, The Peter Norton Family Foundation, the MOCA Contemporaries, and the New Media Project.
Additional support for the exhibition catalogue has been provided by Art for Arts Sake.

Exhibition Tour
The Museum of Contemporary Art, Los Angeles
16 September 2001 – 20 January 2002
Solomon R. Guggenheim Museum, in collaboration with the Public Art Fund, New York
Spring 2003
Hirshhorn Museum and Sculpture Garden, Washington, D.C.
Summer 2003

Senior Editor: Lisa Mark
Editor: Jane Hyun
Assistant Editor: Elizabeth Hamilton
Art Direction: Bruce Mau Design Inc., Bruce Mau with Catherine Rix, Chris Rowat, and Amanda Sebris
Typesetting: Archetype and Moveable Type, both Toronto
Printer: Litho Acme, Montreal

© 2001 The Museum of Contemporary Art, Los Angeles
250 South Grand Avenue, Los Angeles, California 90012

First published in the United States of America in hardcover in 2001 by The MIT Press, 5 Cambridge Center, Cambridge, Massachusetts 02142.

Library of Congress Cataloging-in-Publication Data

Gordon, Douglas, 1966 – .
 Douglas Gordon / organized by Russell Ferguson ; edited by Russell Ferguson ; contributions by Michael Darling . . . [et al.].
 p. cm.
 Published to accompany an exhibition presented by the Museum of Contemporary Art, Los Angeles, Calif., Sept. 16 – Jan. 20, 2002.
 Includes bibliographical references.
 ISBN 0-262-06222-4 (hc. : alk. paper)
 1. Gordon, Douglas, 1966 – — Exhibitions. 2. Video art — Scotland — Exhibitions.
3. Installations (Art) — Scotland — Exhibitions. 4. Photography, Artistic — Scotland — Exhibitions.
I. Ferguson, Russell. II. Darling, Michael. III. Museum of Contemporary Art (Los Angeles, Calif.).
IV. Title.

N6797.G66 A4 2001
709′.2 — dc21 2001041066

Printed and bound in Canada